D0841320

THE
JERSEY SHORE
THRILL
KILLER
RICHARD BIEGENWALD

JOHN E. O'ROURKE

THE
History
PRESS

Published by The History Press
Charleston, SC 29403
www.historypress.net

Cover images courtesy of the Library of Congress.

First published 2014

Manufactured in the United States

ISBN 978.1.62619.287.4

Library of Congress CIP data applied for.

Notice: The information in this book is true and complete to the best of our knowledge. It is offered without guarantee on the part of the author or The History Press. The author and The History Press disclaim all liability in connection with the use of this book.

This book is dedicated to my wife, Ann, whom I love dearly and have spent the last twenty-five years of my life with. I'd also like to express my appreciation for my two grown children, John and Joanna, who are always supportive of my endeavors.

Contents

Acknowledgements

I n researching this book, the following news media were extremely helpful: the *New York Daily News*, the *New York Times*, the *Asbury Park Press*, NJ.Com, the *Courier Post*, the Associated Press, the *Red Bank Register*, the *Bayonne Times*, Wikipedia.com, the *Bangor Daily News*, TV 34 Freehold News, Youtube. com, the *Staten Island Advance*, the *Victoria Advocate*, the *Daily Register*, the *Reading Eagle*, the *Herald-Tribune*, the *Express Edition*, the *Daily Mail Edition*, the *Tyrone Daily Herald*, the *Daily Times*, the *Gaveston Daily News*, the *Morning Herald*, the *Wellsville Daily Reporter*, the *Lubbock Evening Journal*, the *Milwaukee Journal*, the *Cumberland Evening Times*, Rick Porrello's American Mafia.com, dreamindemon.com, ancestry.com, philly.com, silive.com, bayonnepd.com, murderpedia.org and tvbythenumbers.com.

Other resources used were the Bayonne Police Department's file on the Sladowski Murder, *State v. Biegenwald* 96 N.J. 630 (1984) 477 A.2d 318, *State v. Biegenwald* 106 N.J. 13, 524 A 2.d 130 (1987), *State v. Biegenwald* 126 N.J. 1 (1991) 594 A 2d 172 and *Biegenwald v. H. Fauver* LW 882.F2d 748, Ronald M. Holmes's book *Contemporary Perspectivies on Serial Murder*, Colin Evans's book *Blood On the Table* and Harry Camisa and Jim Franklin's book *Inside Out: Fifty Years Behind the Walls of New Jersey's Trenton State Prison*.

Most important to my research was the time afforded to me by the many people involved in the case. Without their cooperation and patience, this book would not have been possible. Thank you to Bayonne police chief Ralph Scianni, Bayonne police officer Ken Macc, Billy Lucia, Kevin Quinn, Mike

Dowling, Bobby Miller, Ken Kennedy, Harry Camisa and Jim Franklin, Guy Spitale, Paul McNicholas and Eric Falks Photography.

Special thanks to James Fagen and Lou Diamond, who spent the most time helping me gain insight into the man one prosecuted and the other defended.

Chapter 1

Bayonne, December 18, 1958

The early morning sun glistened on the waters of the Upper New York Bay. From a distance, cars could be seen traversing the picturesque Bayonne Bridge. A bit closer, ferries were transporting people across the waterways into New York, Staten Island and New Jersey. People on all sides of the water were getting ready to begin their days. In the city of Bayonne, Christmas decorations adorned many of the shops, trees and houses throughout town; the Christmas season of 1958 was in full effect. The date was Thursday, December 18, and there were only seven more days left to shop before the holiday.

As the rising sun began to lighten the dark Bayonne streets, store owners could be seen sweeping the sidewalks, setting up decorations, putting out displays and bringing in supplies for the weekend. The spirit of the season was in the air, and Christmas tunes could be heard everywhere. The most popular of the season was the "Chipmunk Song." For the first time, the animated characters Alvin, Simon and Theodore were introduced to the world. It was a time in America when the term "rock-and-roll" was new, sweetshops were the popular hangouts for teenagers and *Gunsmoke* was the number one show on TV. Sports heroes on the backs of newspapers included the likes of Willie Mays, Whitey Ford, Mickey Mantle and Ted Williams. The year 1958 was a good one in sports for the East Coast teams; in October, the New York Yankees ended the baseball season by defeating the Milwaukee Braves 6–2, winning the World Series for the eighteenth time. And the New York Giants were 9-3 and on their way to the playoffs.

It was an interesting year, to say the least. In January, fed up with the Ku Klux Klan and its cruel and aggressive actions, a local tribe of Indians known as the Lumbees of North Carolina attacked the KKK in an incident later to be called the Battle of Hayes Pond. In February, a Mark 15 hydrogen bomb was lost off the waters of Savannah, Georgia, and to this day it has not been recovered. In March, a U.S. B-47 accidently dropped an atomic bomb on Mars Bluff, South Carolina, causing a mushroom-cloud explosion. Fortunately, the core was not attached, which prevented a nuclear blast. In July, President Eisenhower signed the Alaska Statehood Act, making Alaska the forty-ninth U.S. state. Two days later, a massive earthquake struck the state, causing a landslide that produced the largest wave ever recorded at a height of 1,740 feet. That same month, Congress created the National Aeronautics and Space Administration, commonly known as NASA. Throughout the year, the United States had been active in its space program; earlier in the year, a test rocket had exploded at Cape Canaveral, Florida. In August, the United States launched Pioneer 0, and in October, operating under the name of NASA, it sent Pioneer 1 into space. In the first week of December, Pioneer 2 was deployed. And on this eighteenth day of August the world's first communication satellite was launched. "This is the president of the United States speaking," said Eisenhower. "Through the marvels of scientific advance, my voice is coming to you via a satellite circling in outer space. My message is a simple one: through this unique means, I convey to you, and all mankind, America's wish for peace on Earth and goodwill toward men everywhere."

It was a year of firsts, a year of accomplishments and a year of change. But for one prominent family in the city of Bayonne, the year would be etched in their memories forever.

And on this very same day, forty-seven-year-old Stephen Sladowski woke, sat up and wiped the sleep out of his eyes as he stumbled out of bed. Trying not to wake his wife, Estelle, and their four children—Estelle, nineteen; Catherine, fourteen; Stephen Jr., eleven; and Robert, nine—he prepared for his day. Closing the door quietly behind him, his face was met with the cold wind coming off the Newark Bay. It was six o'clock in the morning as he walked to his grocery store just a half block away. The temperature was a brisk twenty-four degrees, and as he walked, he could see dim lights in several of the homes as people began to rise. Sladowski was off to an early start, but not any earlier than on any other day. He and Estelle owned a store at 168 Avenue B that sat on a street comprising mostly one- and two-family homes. It was a perfect location, so he presumably thought the store could

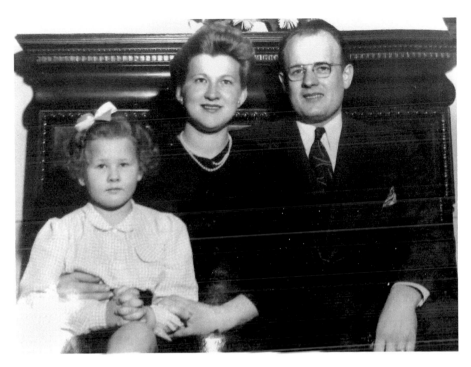

Sladowski with his wife and eldest daughter. *Courtesy Bayonne Police.*

serve the community; it was also conveniently a stone's throw from his house at 130 West Forty-sixth Street.

Stephen Sladowski was a successful and well-respected man. A 1945 book entitled *Prominent Families of New Jersey* illustrates this with a section dedicated to him:

> *Soft-spoken…with a quick smile and a kind word he was a leader for years in civic and church affairs. A devout Catholic, Sladowski joined the Holy Name Society and rose to be its president. The society is an association of adult Catholic males who undergo a vigorous vetting process studying the history of the organization, their rules, mission, objectives, and a pledge of indoctrination is taken. Once completing this process a member or apostolates—as they are called—must adhere to the mission of the society by helping to "feed the hungry, clothe the naked, give drink to the thirsty, shelter to the homeless, [and] tend the sick."*

All of this, Sladowski did his best to fulfill. Having strong faith and devotion, he dedicated his life to volunteer work and community caretaking

and was a "staunch" democrat, attending regularly the meetings of the Democratic Club in town.

The Sladowski home is nestled in a sought-out section of Bayonne, just a half block east of Bayonne Park, which is a spacious one-hundred-acre retreat occupying land on the east bank of Newark Bay. A half block up from his store was St. Vincent's Catholic Church, where Sladowski was a parishioner. An attorney by profession, Sladowski, along with his wife, had recently become a store owner. With the economy in recession, it is remarkable—and a testament to his success—that they were able to make such an investment. Owning a store had to feel natural, as his parents, Frank and Bessie, had owned and operated one while he was growing up.

Both his parents were born in Poland and immigrated to the United States, settling in Bayonne, where they became naturalized citizens. As a child, young Stephen attended the Mount Carmel Grammar School in town and the public high school. Upon graduating, he attended Fordham University in New York City, where he completed his undergraduate work. Thereafter, it was off to Chicago for studies in law at the John Marshall Law School.

After becoming an attorney, Sladowski returned to Bayonne—a place he considered home and where he wanted to raise a family. The city of Bayonne has a sweeping history and was once occupied by the Lenni-Lenape Indians, who fished in the waterways surrounding the city. Formed in 1861 by merging several townships together, Bayonne derives its name from an old crosstown road known today as Thirty-third Street. Bayonne is situated on a peninsula surrounded by Upper New York Bay, Newark Bay and the Kill van Kull. Directly across the Kill van Kull sits Staten Island, and across the Upper New York Bay rests the borough of Queens, New York. Over the Newark Bay waters lie the cities of Newark and Elizabeth in New Jersey.

Bayonne's first mayor was an industrious man named Henry Meigs Jr. Meigs sat on the commission that helped lay out the city's street grid. The street system design consists of streets running east and west and avenues and boulevards running north and south. Just off the water of the Kill van Kull sits First Street; from there, city streets run to Fifty-eighth Street at the opposite side of town. The three major thoroughfares running north and south are JFK Boulevard, Avenue C and Avenue E, most of which run the length of the city.

Despite having nearly seventy-four thousand residents, Bayonne has the look and feel of a small town. One- and two-family homes with commercial businesses line the majority of streets. Commercial centers in town have an array of offerings, from seafood fresh off the local port, to vegetables

and fruits, to fine dining. The residents are mostly blue-collar workers from the manufacturing, distribution, oil and maritime industries. There are immigrant neighborhoods of Italian, Polish and Czechoslovakian descent throughout town. Most notable in town is the Bayonne Bridge with its beautiful arch design conceived by Othmar Ammann, a Swiss-American structural engineer responsible for the designs of the George Washington Bridge, the Tri-borough Bridge, the Bronx-Whitestone Bridge, the Throgs Neck Bridge and the Verrazano Narrows Bridge. The Bayonne Bridge is composed of steel trusses built into an arch that rises 266 feet above the water of the Kill van Kull. The bridge itself stretches 5,780 feet from Bayonne to Staten Island, and when it was opened, it became the longest steel arch bridge in the world. Built by the Port Authority of New York (now known as the Port Authority of New York and New Jersey), the bridge roadway carries two lanes of traffic in each direction on designated route NJ 440, with travelers having to pay a toll heading into Staten Island.

Sladowski was an average-looking man with a lean build, brown hair and a receding hairline. He had a fair complexion, wore glasses and always had a warm smile that made people feel comfortable. Born in April 1911, Sladowski became a stern municipal court prosecutor while in his early thirties. His wife, Estelle, was a strong woman with golden brown hair, nice facial features and an attractive smile. In the mid-1950s, Sladowski partnered with his longtime friend Leo Bergman and opened a firm at 545 Broadway, practicing general law with a strong focus on "the difficulties of people of foreign derivations." His local government interest led to him taking the position of director and council to the Bayonne Community Chest.

Arriving at his store on this cold December day, he unlocked the door and slipped inside. The store was warmer than outside but still a bit chilly. In preparation for the holiday, his wife had decorated the store with Christmas ornaments and put a large wreath in the front window. The store was quite large, with twelve-foot ceilings and exquisite tin tiles. Elevated from street level, one had to walk up several steps to enter the establishment. Two large plate glass windows composed the front façade, where fruits and vegetables, dairy and "White Rose Tea" signs were on display. Sladowski wasted no time preparing for the day's business, as there were items to be placed on shelves, food to be taken out of the refrigerator and paper goods to be replenished. Putting on a white apron, he got to work.

About seven o'clock in the morning, Estelle woke up and prepared the children for school. She then dressed herself and washed the dishes in the sink before heading to the store so Stephen could go to his law firm.

Arriving at about 8:30 a.m., she immediately began cooking breakfast in the back kitchen. Every morning, the couple would have breakfast with Estelle's sister, who worked in the store, and her husband. As Sladowski was finishing his chores, the aroma of breakfast permeated the air. After breakfast, he left for his law firm.

Chapter 2

"Have Gun—
Am Traveling"

Across the waters of the Kill van Kull, another man woke to begin his day. His name was Richard Biegenwald. Now eighteen, Biegenwald was a problem youth who had been in and out of hospitals and mental institutions from the age of five. Friends did not exist for him, as he wasn't capable of maintaining friendships, despite his high intellect and articulate speech. His deportment was cold, callous and threatening, and without notice, he could become enraged and cruel. One minute he was friendly and the next, mean. Biegenwald was a good-looking kid with reddish hair that turned blond in summer. He wore it on the long side with strong comb strokes visible because of the gel he used. People described Richard Biegenwald as cold, but each account of the man always mentions his bright blue eyes contrasted by his red hair. He was not a big man, standing only five feet, eight inches, and weighing 145 pounds. Despite his smaller stature, his cold, blank facial expression and strong New York accent could send a shiver down the spine of a bigger man.

In August, he turned eighteen while sitting in an Asland, Kentucky federal reformatory. He had dropped out of high school and traveled to Nashville, Tennessee, where he stole a car and was caught transporting it to Kentucky. He was charged with transporting stolen property across state lines and spent most of the year behind bars. Recently released from jail, he was up to no good once again. This time, Biegenwald wanted to do something he had been fantasizing about since he was young. Fueled by that fantasy, his uncontrollable urge was calling for action. This desire—or thrill, if you will—existed in him from early on.

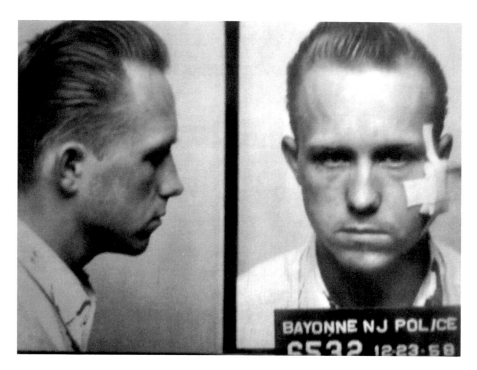

Biegenwald's mug shot. *Courtesy Bayonne Police.*

During the last weeks of November and the first week of December, Dick—as he was called during this period—had gone over to Bayonne on Friday nights and Sunday afternoons for (he said) skating. For most kids, skating was enjoyable because it created an opportunity to meet new people and have fun; for Dick, he saw opportunity elsewhere. In all probability, his trips to Bayonne were in fact dry runs, testing the ferry system from Bayonne to Staten Island. The small-town atmosphere of Bayonne, with its mom and pop commercial establishments mixed with residential neighborhoods and an easy-to-navigate road system, was more appealing than the laughing and smiling faces at a skating rink.

The ferry system, in operation since 1750, transports people across the Kill van Kull to both shores. The first ferry was a small, open scow propelled by oars; the modern one is operated by an engine, with passengers being able to sit inside or out. Considering what would follow, the ferry system proved to be the best route to exit Bayonne—or at least so Dick Biegenwald had concluded.

In the first days of November, Dick met James Sparnroft through a mutual acquaintance. Sparnroft—or Jimmy, as Dick called him—was eighteen and

16

came from Staten Island. He had a slim build, weighing about 155 pounds, and long black hair that he wore in a pompadour reminiscent of Elvis Presley. With his dark hair and green eyes, Sparnroft was a good-looking kid whom others called "Elvis" or "Presley." Raised in a God-fearing Catholic home, his parents taught him right from wrong and to have manners. However, in 1954, an incident in Bayonne caused the Staten Island youth to be arrested. Standing five feet, eleven inches, and with a strong New York accent, he towered over the shorter Biegenwald. Whereas Sparnroft seemed to have a normal upbringing, Biegenwald did not. While Sparnroft was attending the public school system, Biegenwald had been committed to hospitals for the mentally ill. It didn't take Sparnroft long to realize the stark differences between them. However, despite this, he continued to hang out with Biegenwald, even though he said Biegenwald was cold, uncaring and a "lunatic."

Sparnroft speaks of an incident in the old Port Richmond section of Staten Island, the oldest community on the island composed of blue-collar workers and lower-income homes. It was once a thriving seaport lined with beautiful Colonial and Victorian houses for the rich; now, those same buildings are lower-income apartments. A few wealthy families still are present, but they are elderly people trapped in a neighborhood in decline. For Biegenwald, this was his type of neighborhood, where mischief and mayhem could go undetected by police, who rarely patrolled this part of the island. "Dick," recalled Sparnroft, "somehow wound up in a liquor store and bought a bottle of Chianti wine." Sipping on the booze, the two met a young woman, whom Dick sweet-talked into hanging with them. They talked under the Bayonne Bridge and then went to John's Street, where they sat on the railroad trestle. According to Sparnroft, they were sitting and passing the bottle to one another with their feet dangling off the trestle when, out of the blue, "Dick hauls off and hits this girl alongside the head with the bottle of wine." Shocked and appalled, Sparnroft expressed his anger but knew enough to let it go. He didn't want to be the next causality.

Both teenagers worked in New York City. Dick was a clerk at Pacher's Inventory Company on Whitehall Street, and Jimmy was a copy boy for Solomon Brothers and Hutzler Company on Wall Street. In the early morning hours of Friday, December 12, the water of the Upper New York Bay was rough and pounding heavily on the hull of the St. George ferry carrying the two to work. As the water rocked the boat, they were immersed in a conversation about a calling card. Dick thought that after "he did a stick-up or robbery," he would leave a card behind. Based on

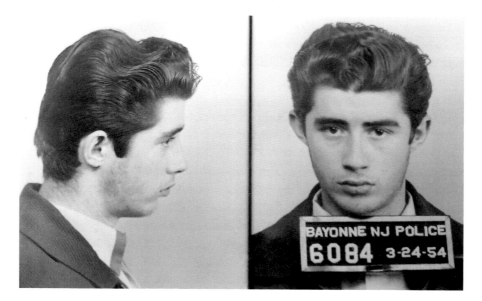

Sparnroft's mug shot. *Courtesy Bayonne Police.*

the popular TV series *Have Gun–Will Travel* starring Richard Boone, the business card Dick wanted would read, "Have Gun—Am Traveling." The protagonist of the show, Paladin, was well educated, well mannered and compassionate—none of the traits associated with Dick Biegenwald. Paladin wore all black, and it is presumed this is where Dick conjured the name "Johnny Black." Sparnroft suggested that a picture of a sawed-off shotgun be on the card as well. "Dick's eyes lit up when I mentioned that," says Jimmy. Dick had always played out fantasies, and it's possible he fantasized about being a professional gun. Years later, his attorney, Lou Diamond, believed he had become just that.

Dick had been planning something—Jimmy knew this to be true. What it was, exactly, remained a mystery. On Monday, December 15, Dick asked Jimmy if he could get a gun. If Jimmy had second doubts about associating with Dick, he didn't show it when he obtained a gun from an acquaintance. Richard McSorley was a hunter with several weapons who knew Jimmy from when he used to watch a neighbor's children. He judged Sparnroft as a decent kid so didn't think anything of the request. McSorley asked what type of gun Jimmy wanted. Jimmy didn't know and said he would find out. Hours later, while sitting in a sweetshop, Jimmy told Dick he didn't get the weapon, and Dick stormed out. The next morning on the ferry, Dick said he wanted a shotgun; by late evening, Jimmy had the gun in hand—a twelve-gauge J.C. Higgins.

That night, underneath the John Street trestle, the two prepped the gun. "I held the rifle while Dick sawed off the barrel and the stock," Spanroft reported to police. By week's end, Jimmy Sparnroft had put together a carrying bag containing ammunition of buckshot and slugs, black mascara, a saw, a flashlight, jumper wires and clips for hot-wiring a car.

On the morning of December 18, just about the same time Stephen Sladowski was eating his breakfast, Dick Biegenwald and Jimmy Sparnroft were on the St. George ferry discussing their rendezvous location for later that night: First Street and Zabriskle Avenue in Bayonne, where the Staten Island ferry lets off.

After work, about 5:00 p.m., Dick stopped at bar where the ferry lets off in Staten Island. The place was a watering hole for longshoremen and the local riff-raff. The tavern had an old mahogany bar with architectural molding showing damage from longshoremen's belt buckles scraping up against it. The lighting was dim and dreary, and dust could be seen on the whiskey bottles lining the wall behind the bar. The bartender was a thin man with greasy black hair that looked like it hadn't been washed in a week. Drinking vodka out of a shot glass, Dick pounded one after another. He had been pounding drinks since he was eight. His problematic youth was often fueled by booze—and it didn't matter what kind. On this night, vodka was his drink of choice, and he sat tucked in a dark corner smoking cigarette after cigarette as he threw back his shots. As he sat there, he had to be running through the night's plans in his head.

At about 9:15 p.m., Dick Biegenwald headed to the Port Richmond area and lurked in the shadows. The sun had long settled into the horizon, and he was dressed in black like his hero, Paladin. He was looking for a car to steal, and the opportunity came when he spotted a cream-colored 1952 Mercury sedan parked on the street at 80 St. Mark's Place. The car was a beauty with chrome bumpers and Whitewall tires. He popped the door and hot-wired the car with what he said was "a pack of cigarettes." Moments later, he was driving over the Bayonne Bridge into Bayonne.

Why Biegenwald and Sparnroft didn't meet in Staten Island, we do not know. Perhaps Biegenwald thought his friend might back out at the last minute; if he got him over the water, there would be no turning back. Biegenwald turned down First Street, shut off the headlights and parked along the curb, where he waited with the engine running.

At about 9:40 p.m., Sparnroft stepped off the ferry and walked toward First Street. He wasn't dressed as if he were going to commit a crime; he wore thick black eyeglasses, a white shirt with a tie, black pants and a

nice-looking, metallic blue, three-quarters-length raincoat. Carrying a canvas bag—blue on the sides and light tan on the ends, which matched his clothing—he looked more professional than criminal. Not knowing where Dick was, Jimmy continued to walk until, out of the darkness, he saw flashing headlights. As he approached the car, the door sprang open and the voice from inside said, "Hop in."

As they drove the Bayonne streets looking for a place to rob, they scoped out a candy store on Fifty-fourth Street. "I put the makeup on him," said Sparnroft. "I put blackface makeup and mascara on him [and] darkened his eyebrows and…his hair," which made Dick's distinct red hair and eyebrows unrecognizable. A nickel-plated knife was used to slit a hole in the raincoat so Biegenwald could "keep his hands on the trigger" when the shotgun was tucked underneath. However, too many people were inside the store, so the boys looked elsewhere. Then they saw an opportunity at 168 Avenue B. The street was mostly residential; many homes were lit with Christmas decorations, and faint Christmas music could be heard in the background. Biegenwald pulled onto Forty-sixth Street at the corner of Avenue B, which was adjacent to a store. He looked in the store and saw a person speaking to a man in a white apron. Lighting a cigarette, Biegenwald sat and waited. Sparnroft sat nervously beside him.

The man in the store was Leo Bergman, Sladowski's friend and business partner. The two chatted as Sladowski cleaned up at the end of the night. His routine was that, after he was done at the firm, he would close the store so Estelle could cater to the kids. The store had been no less busy than his day at court, but it had slowed down by the time his partner arrived. As they talked, a sole customer wearing a long "Oxford gray car coat and a brim hat" came in and ordered a half pound of cheese. Bergman thought the man unusual but then gave him no more notice. Ten minutes later, the two men said goodbye, and Bergman left. As he walked to his vehicle, Bergman saw the cream-colored Mercury parked with its engine running and wondered what it was doing. "I glanced into my rear mirror and noticed the car…backing up that was the last I saw of it," Bergman told investigators.

"Get behind the wheel!" shouted Dick as he stepped from the vehicle, tucking the sawed-off shotgun under his raincoat. Jimmy sat nervously watching his friend walk toward the store. Dick put his wool hat on his head as he climbed the steps to the door. Pushing the door open, cold air swept across the warm floor. Looking around, Dick saw rows of shelving lined with various food items and remnants of a cheese order still present on the countertop. The store was empty, as he hoped, and he saw Sladowski bending

over, placing items under the counter. Dick Biegenwald had committed thefts before—stolen cars, broken into homes—but deep down inside, he knew he was about to take it to the next level. He had killed animals before, even tortured them, but now he was about to take things further. His adrenalin was flowing, and his heart was pounding. Dick felt good—even thrilled.

After putting the items away, Sladowski stood up and was startled to see a man standing there. A closer look revealed that the man had a gun. Not easily intimidated—after all, he served monthly as a criminal prosecutor—Sladowski just stood there. "He would not give up his money," Dick would later tell Jimmy. The gun was loaded with a professional cocktail of buckshot with an alternating round of slug a solid bullet. This is normally done so the shooter doesn't have to aim his first shot. "I couldn't miss from four feet away," Biegenwald later bragged. Sladowsky fell mortally wounded, and Dick took the wallet from the bleeding man. However, he left the cash register alone.

Sparnroft heard the shot, grasped the steering wheel and sat there white-knuckled. Seconds seemed like minutes. "Let's get out of here!" Dick shouted as he hopped in the back of the car. In a panic, Sparnroft pounded his foot on the gas and turned a hard left onto Avenue B, crossing into the opposite lane. Biegenwald rolled down the window and fired a blast, shattering the storefront window. After traveling nearly a quarter mile, Dick jumped over the seat and took the wheel, weaving through back streets as they headed for the ferry.

Emil Kapusta sat watching TV in the apartment above the store. His wife was out for the evening, and he was enjoying a wrestling match. The couple owned the building and had known Stephen Sladowski for twenty-five years. Kapusta had signed a three-year agreement with his tenant, receiving $115 a month. "I heard a loud explosion," Kapusta reported. He went to investigate when he heard a second blast ring out. Rushing down to the store, he was met by eighteen-year-old Donald McLaughlin, who was running for help.

McLaughlin and his friends James McGrady, Robert Gibbons and Jeffrey Stabile were on the street when they heard the blast. Seconds later, they saw a man run from the store and hop into a car. As the car sped away, they saw a bright flash and heard a loud pop. McLaughlin and Jeff memorized the license plate: New York, RD-757.

Abandoning the car on Zabriskle Avenue near First Street, Dick and Jimmy headed on foot to the ferry. A short, brisk jog across the Kill van Kull to Staten Island and the two would be safe. The weather remained clear, and the ferry moved through the water smoothly. The moonlight cast a bright

glow on the black water; to the right, they could see the lighted Bayonne Bridge in the foreground. The air was chilly for those on the exterior portion of the ferry, but not for the two fugitives, whose blood was pumping rapidly through their veins. Dick held on tightly to his shotgun, which was once again tucked under his raincoat.

Chapter 3

Getaway

The phone rang at police headquarters at 9:52 p.m. The desk sergeant who picked up heard the frantic voice of Donald McLaughlin calling for help. Police radio waves sounded with alerts, and officers converged from all directions on the small grocery store. The quiet neighborhood was filled with flashing red lights, police cars strewn all over and uniformed cops cordoning off the area while people gathered to see the commotion. When the onlookers heard it had been Stephen Sladowski who was killed, they were mortified.

Police officers Carmelo "Tommy" LaRocca and Edward Adamski were among the first on the scene. Tommy Larocca was a seasoned cop who was awarded the city's Valor Award in 1947. Larocca had a dark Italian complexion with brown hair and eyes. Tommy wasn't a big guy; he stood only five feet, seven inches, and the wind could knock him about, as he weighed less than 150 pounds. However, he added to his weight by carrying a Colt .38-caliber handgun. Larocca was practically a neighbor of Sladowski's; he lived off Kennedy Boulevard. Ed Adamski carried two weapons, both .38 caliber—one a Colt and the other a Smith & Wesson. Adamski was a much bigger man than LaRocca, standing nearly six feet tall and weighing a hefty 200 pounds. He, too, had brown hair and eyes with a ruddy complexion. Adamski would one day rise through the ranks to be police chief. Pulling up to the store, both men could see a crowd already forming. Some were standing outside, and some were even inside the store. Broken glass was everywhere, and as the two officers rushed into the store, they heard the sound of glass

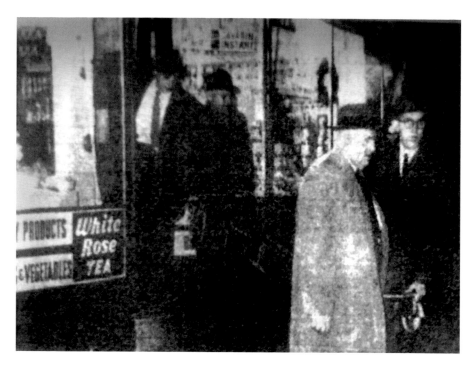

Sladowski's body is carried out of the store. Bayonne Times *photograph.*

being crushed under their feet. It was a horrific sight, with Sladowski lying motionless in a pool of blood near the doorway to the upstairs apartment. Blood, flesh and bone fragments were strewn on the floor and wall. The victim's face wasn't visible, but they knew who he was. The two strong cops fought hard to keep back tears.

Police chief Cornelius Carroll received a call informing him of the murder. Sitting up in bed, Carroll whispered to his wife that he had to leave, and out the door he went. Carroll was a stern, square-jawed cop who saw his share of blood and guts patrolling the city streets. Every murder in his city was a tragedy, but this one struck close to his heart. Carroll had been friends with Sladowski and his family for years. The department Carroll led was rich in history, dating back to 1869, when the force was created. Then, it had only three police officers; now, there were hundreds. Initially operating out of the Twomey Hall building on Twenty-second Street, the Bayonne Police had become a highly respected department. The turn of the twentieth century witnessed the Bayonne Police using the Gamewell Police Telephone System, which consisted of call boxes placed at strategic locations throughout the city. For three decades, these call boxes served as the only

means of communication between street cops and police headquarters. In the early 1930s, the department began using a two-way radio system, making it the first time headquarters could speak directly to a patrol car via radio. Proactive policing had been a hallmark of the force, and Carroll strove to continue that tradition. He was going to use all the resources available to him to find the killer.

As investigators worked inside and out of the crime scene, the night temperature dropped to a chilling twenty-four degrees. What heat there was in the store was overtaken by the brisk wind streaming through the shattered storefront window. Investigators spent several hours determining what had occurred. Photographs were taken, and a diagram was sketched out. Eventually, the body was removed and brought to the city morgue, where an autopsy was planned for the morning.

Sometime close to 3:00 a.m., police discovered the getaway car in a vacant lot off Zabriskle Avenue. Biegenwald had "wiped the car clean" but missed a fingerprint on the rearview mirror, which was discovered by investigator Thomas Heaney. Afterward, the FBI was called in to help process the car and provide investigative perspective and support.

The discovery of the car baffled police because it was found at a confluence of routes that led out of the city. A bus stop was near the housing complex, the ferry was a block away and there was the chance the fugitives had abandoned one car for another—all possibilities had to be pursued. Dick Biegenwald was cunning and knew that leaving the car at that location would buy him the time he needed to cross the water. However, by the time police discovered the car, both Biegenwald and Sparnroft were fast asleep in their beds.

Carroll cancelled all time off for the department; he needed people to investigate the murder, as well as officers to cover normal police services. As it turned out, this was a busy night for the department, as a burglary on the opposite side of town resulted in the theft of over $3,000.

As Bayonne Police were knocking on doors, other investigators were checking out the booth on the Bayonne Bridge. This—like the action at the housing complex—didn't reveal any information. Investigators then spoke with the captains operating the ferries, and once again this proved a waste of time.

Chief Carroll called a press conference in the early morning hours with local and state media in attendance. "I knew Mr. Sladowski for many years," Carroll reported after being asked if he thought Sladowski might have tried to fight back. "He was too intelligent a man to do a foolish thing like that.

It they wanted money, he would have given it to them." Carroll said the killing was senseless. He provided a description of the subject as five feet, ten inches; having a slim build; and wearing a waist-length, zipper-type jacket with his hair and eye color unknown.

The next morning, on Friday, December 19, Estelle Sladowski and her children were emotionally drained and sleep deprived. The new day brought a drastically changed life for their family.

Across the Kill van Kull, Jimmy Sparnroft woke from his slumber, had coffee and dressed for work. It was 6:45 a.m. when he headed for the ferry. As the day progressed, he hadn't heard from Biegenwald. At 5:00 p.m., the phone rang at work, and it was Dick. "We have got to leave town."

"Why?" Jimmy asked.

"The fellow…died."

"I didn't do anything," Jimmy nervously said.

"Doesn't make any difference…[you're] in the same boat," Dick said.

Deep down, Sparnroft knew this to be true. He had supplied the gun, the ammo and even the raincoat. He had colored Biegenwald's hair and driven the getaway car. He was up to his eyeballs in it.

"PROSECUTOR MURDERED…Sladowski Shot Down in His Store; Stolen Getaway Car Located Here," read the headline for the *Bayonne Times* newspaper. The *Staten Island Advance* had a similar headline, and Jimmy presumable felt nauseous when Dick showed him the paper.

Bayonne police were already combing Staten Island trying to find clues to the case. On the Jersey side, they were again interviewing the four youths who had witnessed the getaway and taking formal statements. Police detectives were thumbing through Sladowski's office files trying to find a lead. "A youth harboring a grudge may have sought him out," a paper suggested. Where the car was discovered on the opposite side of town was curious to police. If robbery were involved, why did the youths drive to Forty-sixth Street rather than hitting a downtown store? Also puzzling was the second shotgun blast. Investigators said there "was no indication [the suspect] saw the youths across the street." So why did he shoot into the store?

Leaving work and heading directly home, Biegenwald and Sparnroft grabbed the shotgun from under Dick's mother's front porch. Between 6:00 and 7:00 p.m., they were in Port Richmond looking to steal a car. "We spotted a car," Biegenwald told police. "I told him [Jimmy] to wait on the corner." Once again, he shorted the ignition with a pack of cigarettes. This time, the vehicle was a 1951 Oldsmobile.

Minutes later, the two were crossing the Goethals Bridge into New Jersey. Where they were going is not known. Presumably, they had no plan. Biegenwald acted solely on gut instinct and turned southbound on the turnpike. The drive was an anxiety-filled trip on a highway rigorously patrolled by New Jersey state troopers. Miles of roadway with open farmlands provided the backdrop as they put distance between them and investigators in Bayonne. Occasional stops for gas, hamburgers and coffee were taken with little conversation occurring. They crossed into Delaware and turned onto the darkly lit roadway known as Highway 13.

Chapter 4

"I Don't Know How We Didn't Get Killed"

The night was clear with a brisk temperature of nineteen degrees and a strong wind rolling in from the east. Just after midnight, Biegenwald drove into the city of Salisbury, located on the eastern shore of Maryland. Salisbury is part of the Delmarva Peninsula, which is composed of parts of Delaware, Maryland and Virginia. Highway 13 is the only thoroughfare that brings travelers from the north into town. Biegenwald turned the vehicle onto East Main Street and saw a police car waiting at the light. Behind the wheel of the cruiser was a forty-two-year-old Salisbury police officer Eldridge Hayman. Standing five feet, ten inches, with a receding hairline and a round face that made him look heavier than his actual weight, Hayman was a seasoned cop who spotted the two boys immediately.

Later speaking of the incident, Dick Biegenwald said he "came upon a red light which [he] did not see until the last minute." Pressing fast on the brake, he stopped right at the white line. "I then took off and drove for three or four miles."

As they drove, Jimmy looked behind them and said, "There is a cop's car in back of us."

Looking into his rearview mirror, sure enough, it was a cop. "I looked over," said Biegenwald, "and he was motioning for me to go onto the side."

Dick Biegenwald slowly pulled his car to the side of the road, slipped the shotgun onto his lap and waited. Looking in his driver's side mirror, Dick saw the cop open his door and begin to approach.

Hayman didn't know the vehicle he was approaching was occupied by two men wanted for murder. As Hayman walked in the darkness, his dimly lit flashlight cast a poor illumination on the vehicle's occupants. He could make out two dark figures, but little else.

"He came up alongside of our car," reported Biegenwald. "I twisted my body and fired a shot."

A bright flash was followed by a hard-hitting thump to Hayman's face. The "pumpkin round" fortunately had only grazed his cheekbone but was still enough to knock him down. "Oh shit, this guy's a lunatic," Sparnroft remembers thinking.

Hayman ran for cover, firing six shots, all of which missed their target and struck the trunk of the car.

"I fired a blast over the car," said Dick, and "jumped in my car and drove." In his haste to get away, he didn't pay much attention to where he was going, and they got lost in a "maze of hills." On the isolated and dark road, they stopped at the intersection of Snow Hill Road (SH-12) and Nassawango Road (SH-354). The location was perfect to gather their thoughts, as four large farms converged at this location with not a building in site. They were deep within the rural woods and fields of Maryland. Pulling out a map, Dick decided to head south on Snow Hill Road toward the town of the same name.

Rather than pursue and keep an eye on the suspects, Hayman, thinking his injury was worse than it actually was, drove to the hospital. He did, however, give a description of the suspects and car to his headquarters, and it was sent to the Maryland State Police.

The state police in Maryland was created after World War I in response to a crime wave that swept the state. The organization was composed of hard, disciplined troopers, many of whom had military experience. The report of a cop shooting doesn't resonate well in the law enforcement community; needless to say, police and troopers alike were out searching for the suspects' car.

One of those listening to the radio broadcast of the shooting was state police lieutenant Carroll C. Serman, a no-nonsense trooper who looked the part. At fifty-one years of age, Serman was an imposing figure. The Maryland troopers' uniform is distinct: olive pants with a black stripe down the side, a tan-colored button-up shirt and a black tie, with the Maryland State Police patch displayed on the shoulder. The uniform was designed to exhibit authority; however, the six-foot-four, 220-pound trooper didn't need a uniform to be intimidating. He was a strong man with broad shoulders and a thick neck. A picture of him depicts a man with dark hair worn in a buzz

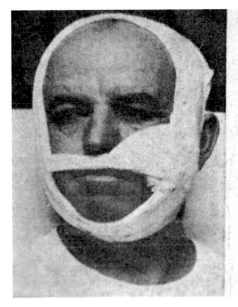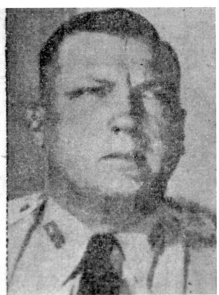

Shootout victim. Salisbury Times *photograph.*

cut fashion, light-colored eyes and rock-like facial features. His look is stern, authoritative and yet appealing

A little after two o'clock in the morning, Serman, driving his green-and-black troop car west on Snow Hill Road about one mile from town, noticed headlights coming in his direction. As the vehicle passed, he saw that it looked like the suspects' car. "I immediately turned around in the road and drove up to approximately fifty feet" from the car, Serman's report read. His headlights illuminated the license plate: New York U-4530, which was the plate provided by Hayman's broadcast. Serman radioed that he had the car in sight and organized a roadblock at an intersection a few miles ahead. Reaching down, he flicked the switch and activated the emergency lights. Dick Biegenwald saw the flashing lights and quickly pulled to the side of the road. "I stood alongside my car behind the headlights," said Serman. "I ordered the two men to get out of the car."

Moments earlier, a soft snow had fallen and blanketed the area. "The scene was surreal," Biegenwald later described. The moonlight shone brightly off the snow-lined pine trees. For Dick, it was as if he were in a scene from *Have Gun—Will Travel.* Playing the protagonist, "I pumped one shot," Biegenwald said, in the direction of the cop. From behind the bright glare of headlights, a yellow flash erupted, followed by a thunderous pop. "I ducked back in the

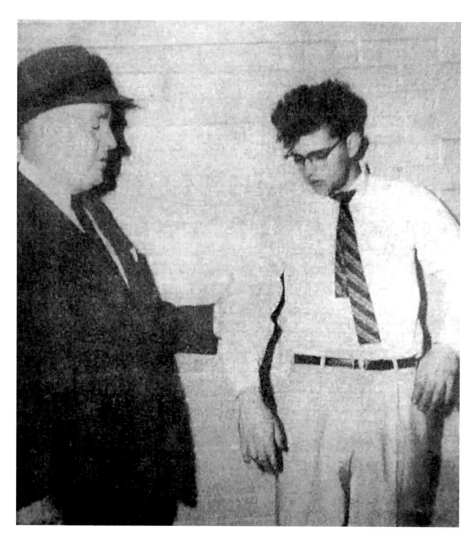

An agitated James Sparnroft (right). Salisbury Times *photograph*.

car, [and] I was shot in the face," says Biegenwald. Serman, although struck in the leg, had returned fire with his .38-caliber handgun and hit his target. Biegenwald fell back into the driver's seat and apparently knocked the car into drive because it rolled into a ditch. Momentarily dazed, he was slow to respond. "I ran up and kicked the shotgun, which he was endeavoring to retrieve," Serman wrote. Dick Biegenwald was bleeding profusely, while Jimmy Sparnroft sat wondering what had just happened. "I don't know how we didn't get killed in this mess...It was like one of the things you see in a

movie. [Biegenwald] jumped out of the car with his shotgun, and he and this stupid ass cop were out there playing OK Corral."

The headlights lit the way along dark stretches of Snow Hill Road some twenty miles through the dense hills and open farmland as the two were transported to the hospital. Looking out the window, with the red flashing lights bouncing off the dark green pines, Sparnroft had to wonder what lay ahead.

At the Peninsula General Hospital, doctors treated Serman's and Biegenwald's wounds while Sparnroft sat and waited. "One of the cops came running in and started grabbing on me," says Sparnroft. "I knocked him on his ass." He may not have looked tough with his business attire and horned rim glasses, but he was. "I don't play that shit. I did nothing to you, don't put your hands on me." Sparnroft, speaking of the whole incident, said later, "They violated our rights, but that didn't matter in those days."

The troopers impounded the Oldsmobile and confiscated the J.C. Higgins shotgun and nose putty, paint, black shirts, black gloves, a box of twelve-gauge shotgun slugs and a box of twelve-gauge buckshot, all of which was contained in the duffle bag.

IN THE DARK ROOM, a loud ring woke Earl Reith and his wife. Reith, a captain with the Maryland State Police, was in charge of the Eastern Shore. A call in the middle of the night was not good news, so he immediately picked up the receiver. The voice on other end spoke of a shooting involving a local cop and one of his own. He was advised that the injuries were not life threatening and the suspects were in custody. Breathing a sigh relief, he hung up the phone, bent over, kissed his wife and went off into the night.

Earl Reith had extensive experience with these types of investigations, and prior to his promotion to captain, he had commanded several state police stations. Unlike most troopers, Reith was not a big man, standing somewhere between five feet, eight inches and five feet, nine inches with a round belly. He had a receding hairline and diminishing eyes, causing him to wear thick black glasses. In fact, he didn't look much like a state trooper at all. His uniform pants were always pulled up high above his belly button, and he wore his belt buckle somewhat off center, not in line with the zipper seam. The somewhat awkward trooper began on motorcycle in 1931, patrolling western Maryland, and through the years, he had proved himself to be an able trooper. Reith's thoughts this morning had to be "Thank God a trooper was not killed." Nine troopers had died in the line of duty during his tenure, with the last occurring just over the summer. About an hour after he picked up that ringing phone, he pulled his car into headquarters, grabbed a cup of coffee and was briefed.

Hundreds of miles north, investigators in Staten Island had spent the night going door to door in the area where Biegenwald had stolen the car but weren't able to come up with anything. It was dead-end after dead-end until a desk sergeant picked up the phone shortly after nine o'clock Saturday morning. A Maryland trooper told him they had in custody the two men responsible for killing the store owner. An immediate call went out to Chief Carroll, who was home totally exhausted from the two-day investigation.

Carroll called Captain Reith, and the two seasoned officials spoke at length, with Carroll telling Reith he was going to head south with a contingent of officers.

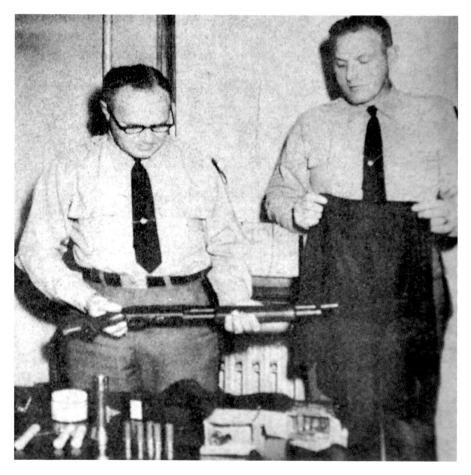

Captain E. Reith (left) and Sergeant E. McGee (right) examine a shotgun. Salisbury Times *photograph.*

A little after noon, Carroll, Inspector Anthony Vatalaro, BCI superintendent Thomas Heaney and Detectives Daniel Petrella, Charles Connors and Jonathan Walker departed headquarters en route to Maryland. The trip was long and uncomfortable, with the officers basically traversing the identical route the fleeing fugitives had taken. They arrived about four thirty at the Maryland State Police station.

The Jersey officers were greeted by Sergeant Edwin McGee, a seventeen-year veteran of the force. McGee was equally as tall as Serman but far less intimidating, and like Reith, he was somewhat uncharacteristic of a trooper. McGee brought the Jersey officers into the station, where Captain Reith waited. Down the hall was Jimmy Sparnroft, who had been picked up earlier in the morning from the county jail. Dick Biegenwald was still in the hospital under police guard.

Charley Connors and Jon Walker opened the holding room door and walked in. They were surprised by the look of the prisoner. He was clean-cut, wearing nice slacks with a white shirt and a striped tie. When Sparnroft looked up, his horned rim glasses made him look more like a victim than a criminal. The two officers went right to work, and the questioning began with Sparnroft cooperating. His account left nothing to the imagination and indicated his lack of participation in the three shootings. It was clear he had not been the triggerman in the Sladowski murder.

It wasn't until about 10:30 p.m. that Connors and Walker arrived at the hospital to question Richard Biegenwald. There, the young man sat up in his hospital bed with a large white patch over his left cheek. He had an IV running into his right arm and a heart monitor behind the left side of his bed. This man, they presumably thought, was much different than Sparnroft. While speaking with him, they realized he showed a lack of emotion and was rather aloof. To them, there was something sinister about him. They looked beyond the blueness of his eyes and saw deeper down into the dark recesses of his soul. He was cold and callous and talked openly about his crimes as if telling a story. Their interview produced a detailed statement from Biegenwald, which he signed.

The following morning, Sunday, December 21, the two prisoners waived extradition, and preparations were made to transport them to New Jersey. As the New Jersey cops readied their car, Chief Carroll thanked Captain Reith and congratulated his troopers for taking these men off the street.

As the sun was setting, the officers arrived at Bayonne Police headquarters, where Assistant Prosecutor Joseph Ochs was waiting. It would be Ochs who would lead the interview, along with city detectives. According to Sparnroft,

"The prosecutor comes down and asked, 'What is your version of what happened?'...I [had] no idea what this idiot was going to do." Out of the blue, Ochs shouted, "You're a motherfuckin' liar!"—words, Sparnroft says, "weren't used back then." Emotions ran high, as everyone took the killing personally. Out of these intense and emotionally driven interviews came two detailed accounts of what transpired, including a physical run-through of the route Sparnroft and Biegenwald took going into the city and going out.

STEPHEN SLADOWSKI WAS LAID to rest at the Holy Cross Cemetery in North Arlington, New Jersey, on Tuesday, December 23, with hundreds of people in attendance. He had meant so much to so many, and it was a sad day for not only the family but the city as well. On Christmas morning, Estelle Sladowski woke and did her best to be strong for her children. From that moment on, the Christmas season was forever stained by the memory of their loved one's death.

Chapter 5

A Troubled Youth

With the two suspects behind bars, authorities began looking into the life of Richard Biegenwald. They acquired a large amount of information for the prosecution to digest. The assistant prosecutor assigned to the case was Edward Zampella, a seasoned prosecutor who just months earlier had been involved in investigating one of the worst train accidents in New Jersey history. A central New Jersey train drove off an open drawbridge into the Newark Bay, killing forty-eight people; it was a tragedy he would never forget. Prosecutor Zampella, sipping on a cup of coffee in his office early one morning, began reading the case file investigators had put together on Richard Biegenwald. The details in the life of the man he was about to prosecute were stunning.

Born on Saturday, August 24, 1940, in Rockland County, New York, Biegenwald's parents, Albert and Sally, were renters at 173 Clove Road in Staten Island. They lived with Sally's father, Roscoe Decker, who was only fifteen years her senior. Sally is believed to have been from Staten Island, whereas Albert was from Pittsburg, Pennsylvania, and was one of three children. As an adult, Albert was of average height and weight and used a prosthetic leg to walk, as he had lost his limb in an accident of some sort. He had sandy blond hair and, with the passing of time, became a heavy drinker. Sally was a small woman—between five feet, three inches and five feet, five—average looking, timid and not well educated. At first, their marriage was warm and affectionate, with Albert supporting them as a steamship clerk for the U.S. Maintenance Company in Manhattan. He was a bright and hard worker who was paid well, garnering $2,500 a year.

Events unfolding throughout the world during the 1940s created a difficult environment for many young couples. There are many causes that led to World War II, and expansionism was certainly one of them. Mussolini began a campaign to create a "New Roman Empire" based on the Mediterranean and invaded Albania and Greece; whereas Germany, under Hitler, wanted to restore what he believed to be Germany's rightful boundaries. As other countries, small and large, aligned themselves with one side or the other, America sat watching—until the attack on Pearl Harbor. Not long afterward, the effects of the war were felt in communities everywhere. In 1942, the production of automobiles was halted, and a year later, the rationing of food supplies began. The workforce was reduced as men went off to war, leaving women and those not eligible for military service to fill the void.

Albert and Sally were doing OK financially, with their cuddly little boy with reddish hair and bright blue eyes at the center of their universe. However, as their son grew, he began displaying behavior that at first was dismissed but later became too troubling to overlook. Medical reports seem to describe his behavior as bizarre, but the specifics of the behavior aren't known. However, doctors eventually classified him as a schizophrenic, and with this diagnosis, we can draw some reasonable conclusions on what they meant by "bizarre." Schizophrenics oftentimes sit motionless in odd postures, and their emotions don't fit normally into the events occurring (such as expressing sadness when happy, etc.). Speech can be garbled, and they move their bodies in repetitive, purposeless motion. Certainly, this behavior was disconcerting for Albert and Sally, and this could be what contributed to an increase in Albert's drinking habits. However, it was almost certain that his drinking wasn't what would tear the couple apart; rather, it was Albert's abusive nature that would do them in. Over time, the verbal abuse turned physical.

As Richard grew, it became even more apparent that something was terribly wrong. He was reclusive, irritable and spent a lot of time daydreaming. As a toddler, he was aloof and overly sensitive to criticism, especially when it was heavy-handed from his father. Sally was a loving mother who presumably feared her husband and did little to quell the abuse, and her son resented her for that. When Richard was five years old, he tried to set the house on fire. It was this event that caused Sally to seek medical attention for her son.

The Children's Psychiatric Hospital in Rockland County, New York, was just forty-five miles north of Staten Island, and for the next three years, Richard would receive residential treatment there. He was allowed home only periodically, mostly on weekends. Some say it was during this period that Richard began torturing animals, while he was home visiting his parents. He

also began displaying antisocial behavior, acting cruel and abrasive toward others. Reports say that at the age of eight, he began drinking, which possibly was a way of mimicking his father's behavior. Several sources indicate that Richard was gambling at this age and smoking cigarettes. He failed to show any progress while at the Children's Psychiatric Hospital, so his mother brought him to the renowned New York Bellevue Hospital.

Bellevue is the oldest public hospital in the United States, having opened in 1736 on First Street in the Kips Bay area of Manhattan. At that time, it was far removed from the citizenry and was used to isolate and treat the "sick." Since then, the hospital has developed a reputation for being one of the best—especially its psychiatric ward.

The large, red brick building had an unsettling vastness to it. Holding her little son's hand, Sally walked up the steps toward the main entrance, which was surrounded by two large extensions on each side. With an abundance of windows, both mother and son could see people dressed in white walking about. The place was eerie and housed a psychiatric ward with over three hundred beds. The emotions felt by mother and son can only be imagined.

Doctors diagnosed Richard Biegenwald as a child schizophrenic and administered a series of electroshock therapy treatments. Today, this treatment is called electroconvulsive therapy, and it consists of short bursts or pulses of electric shock into the individual. The device is hooked up to one or both sides of the patient's head for the delivery of the treatment. The treatments are believed to provide relief from psychiatric illness. After each session, Richard was wrapped in wet towels and left on a gurney shivering; he would urinate on himself to help keep warm. On average, he received two or three treatments a week, with a total of twenty electroshock therapy sessions administered.

It became evident to Sally that her son was unable to function without intense supervision, so arrangements were made for him to reside at the State School for Boys in Warwick, New York. Some sixty miles west of Manhattan, the school was created in the fall of 1933 to help delinquent boys who were consistently in trouble. Here, it was believed the boys, now removed from the inner city, could focus on education and bettering themselves. Through positive interaction with teachers who understood their difficulties, these troubled youths could succeed in society—or so it was believed. Fresh air and a beautiful country setting provided the backdrop for the training in farming, woodworking and other trade skills.

From the onset, Richard failed to comply and showed a rebellious nature, socializing with the more troubled boys. Psychologists said he "suffered

from night terrors" and fantasies about death. Rather than make friends, he organized a group of youths into helping him escape. The attempt was foiled, and he was placed under strict supervision. On his visits home, he would steal money from his mother, and on at least one occasion, he was found breaking into a neighbor's house. Years later, he would boast about this skill: "[I] could get into anyplace if [I] wanted." Richard showed little improvement, and he became increasingly frustrated, with his thoughts of death coming more frequent. One doctor said Richard had an "extreme fantasy of death." Then, at the age of eleven, while on a home visit, he set himself on fire.

It was clear the child was seriously troubled, and while the course of treatment doctors administered after the fire incident isn't clear, it seemed to have a calming effect. This deduction is based on Richard's release from medical supervision at age sixteen and his being allowed to enter the mainstream educational system. The year was now 1956, and Albert and Sally had long separated; by year's end, they would be divorced.

For the first time since he was five, Biegenwald was attending school and socializing with kids his own age. However, he failed to show interest in learning and was arrested several times for stealing cars. Nearly two years later, he dropped out of school and headed to Nashville, Tennessee, where he stole a car and was later arrested in Kentucky. Speaking about his son to a newspaper reporter, Albert said, "That kid has always been bad."

It was a troubling story, one that led to the prosecutor, at the behest of Edward Zampella, to not seek the death penalty. Even Estelle Sladowski asked the court to be lenient on the boy.

Chapter 6

Life in Prison

There would be no trial, as the two men entered pleas of *non vult* (no contest) on June 15, 1959, with the sentencing taking place on Tuesday, August 4. The setting was the beautiful six-story Hudson County Courthouse in Jersey City. Constructed in the Beaux-Arts architectural style popular in the United States during the early twentieth century, the exterior veneer is made of granite and has four Corinthian columns and a frieze above the main entrance with the inscription: "Precedent Makes Law; If You Stand Well, Stand Still." Those not familiar with the courthouse were amazed when entering the lobby. Besides its large open space, the walls were composed of gray- and green-veined marbles with bright gold light fixtures overhead. Other walls were painted in bold colors of yellow, green and blue, and standing in the lobby, one feels almost consumed by its great size.

The two young men were brought into the court and stood before Judge Furman W. Reeves, a no-nonsense judge dressed in the customary black robe. Richard Biegenwald wore a dark suit and tie, while James Sparnroft contrasted him with a white suit and dark tie. Biegenwald's attorney, New Jersey assemblyman Alan Kraut, was a respected politician and lawyer, and Sparnroft's attorneys were Maurice Krivet and Nicholas Regi, both well-known defense lawyers from Staten Island. In the courtroom listening to the hearing were Sally Biegenwald and Sparnroft's mother. Kraut opened his statement by asking for leniency, telling Reeves that his client, at nineteen, had spent ten of his years in mental institutions. What he needed was help and guidance, which, Kraut suggested, he had not yet received. "He

has the potential for being a fine citizen," said Kraut. "Perhaps he is here today because someone in one of those institutions did not provide the rehabilitation treatment."

Reeves sat high above the bench and didn't say a word. Sparnroft's attorneys told the court their client was a victim of circumstances. "He," Regi said, speaking of Sparnroft, "was a cowardly dupe who did not know what Biegenwald was up to."

Judge Reeves broke his silence. "Your client is the boy who got the gun. Your client is the boy who purchased the shells. He is the boy who sawed off the shotgun with three files under a trestle in Staten Island. He is the boy who cut the right-hand pocket of the raincoat so the gun could be concealed."

Regi tried to "answer with a series of 'yes, buts'"; however, Reeves would not allow it.

"By the way," Reeves added, "have you noticed that no one here in court has mentioned the name of Stephen Sladowski. He stood where you are now and pleaded his last case. He was one of the finest lawyers in the county, a public official, one of the finest, clean-cut men I ever saw in court—a man of integrity, a man with a fine wife and family."

Sparnroft and Biegenwald are escorted into court. Bayonne Times *photograph.*

Alan Kraut moved closer to the bench and said in a soft respectful voice, "[I] intended to speak of Mr. Sladowski," as he knew him personally. "His slaying was a dastardly deed. But we are here today as advocates. And the true test of advocacy is in representing unpopular causes of persons."

Assistant prosecutor Edward Zampetta said he had only one comment: "Let us not forget the cold-blooded killing."

The sentencing concluded with Biegenwald receiving a life sentence and Sparnroft getting twenty-five to thirty years; both, however, would one day be eligible for parole.

IT WAS LATE SUMMER when Richard Biegenwald entered prison, a place where he would have to learn how to exist. This was not an easy task in Trenton State, especially for a nineteen-year-old. The prison, built of hard rock and brick, is situated on the south side of Newark, New Jersey, a tough neighborhood, inside the walls of prison and out. The prison was built in 1798 and became the third state prison in the United States and the first in New Jersey. In 1832, an extension to the prison was built, and a third followed years later.

The population of the prison in the late 1950s was predominately white, and the customary punishment for misbehavior was bread and water rationing. The environment was harsh, even for the most hardened of criminals, let alone a teenager. During the first few months, Biegenwald was challenged by several of the more tenured prisoners. Time and again, he proved his strength and showed he wasn't intimidated. In doing so, Biegenwald ended up several times in solitary confinement for the standard ten-day period of punishment. That, too, was part of a prisoner's way to establish himself among the general population. The punishment in solitary came with food rationing of four slices of bread and fourteen ounces of water three times a day. To Richard Biegenwald, this was nothing compared to the electroshock treatment of the past.

Prison didn't seem to bother him, according to Harry Camisa, author of the book *Inside Out: Fifty Years Behind the Walls of New Jersey Trenton State Prison*. Camisa was a guard when Biegenwald first arrived in 1959. "He kept to himself; he's cold!" says Camisa. In his book, Camisa says his first impression of Biegenwald was that he was "bright and articulate." As the years passed, the guard developed a working relationship with the man, and although he had many conversations with Biegenwald, Camisa "could never figure him out." Biegenwald was able to exist in prison without anyone bothering him because everyone knew he "was not afraid to die," says Camisa. One incident in particular Camisa tells to support this claim is when a rather large prisoner tried to get Biegenwald to pay for protection. Biegenwald had

confided in Camisa and told him he grabbed a piece of metal from the repair shop and confronted the man. "You wanna go for broke…Go for it." The prisoner never bothered Biegenwald again.

By the dawn of the 1960s, Richard Biegenwald was turning twenty, and while he aged between four concrete walls, the new decade was unfolding. The United States became deeply entangled in the Vietnam conflict, President Kennedy was assassinated and Martin Luther King and Robert F. Kennedy were both murdered. The sexual revolution was off, and American music was stormed by the British Invasion. Within the cold gray walls of prison, Biegenwald was working in the machine shop, learning to weld and build working parts of machinery. Between 1962 and 1964, he was put into solitary confinement for being in possession of gun parts and ammunition. He had created these parts himself while in the shop. He was perfecting a skill he would one day use in the basement of his Asbury Park Apartment. After reentering the general population, he was moved to the prison's print shop. The following year, 1966, Biegenwald got into a fight, the specifics of which are not known. The seriousness, however, can be gleaned by his eleven-month stay in solitary confinement.

Throughout his tenure in Trenton State, the prison population slowly changed from predominately white to mostly black, and the subculture changed as well. Drugs were now the prized commodity instead of cigarettes. However, for Biegenwald, cigarettes would be his most treasured possession, as he smoked upward of three packs a day. His once neatly combed hair was now a disheveled mess, and he seemed to always have a five o'clock shadow.

In April 1967, he was transferred to Rahway State Prison in Avenel, New Jersey. When the prison transport drove Biegenwald down Production Avenue leading to Rahway State Prison, the large red brick structure with its great dome presented a different view for him. He knew if he played his cards right, he stood a chance to get paroled in a few years when he became eligible. He was only nineteen when he entered prison; a sympathetic parole board might give him another chance. As the cold steel bars of Rahway closed behind him, a dim light began to appear at the end of the tunnel.

Rahway State Prison has a long history dating back to the late 1800s, when it was a reformatory. It is known for its red brick architecture, with each wing expanding out from the center dome, forming an X. By the 1930s, Rahway had transitioned into a prison for male convicts. By the 1970s, it had a reputation for being a hardened prison with a troubled past. This is the place where the *Scared Straight* documentary of the late 1970s was filmed. That film

centered on hardened criminals of Rahway, terrifying adolescents in the hope of preventing them from going down a path toward a life of crime. One of the participants was a young, dark-haired man with thick eyeglasses named James Sparnroft. Biegenwald's cell was just one floor up from that of his old friend and getaway driver. One might think the two former accomplices would have reunited, but that wasn't the case. "I didn't want nothin' to do with him," touts Sparnroft. By his account, the two avoided each other at all costs.

Biegenwald worked in the prison dental lab making false teeth and seems to have avoided trouble during his tenure. Illustrative of this is his lack of participation in and disconnect from one of Rahway's worst moments.

It was Thanksgiving 1971, and Americans everywhere were home enjoying the day and watching football when a news bulletin was broadcast about a riot taking place inside Rahway State Prison. The warden and five guards were being held hostage. "Negotiations now are underway between prisoners and administrators," the news reported. It was a heated situation, with prisoners claiming the reason for the upheaval was poor treatment, abuse by guards and lack of medicine, coupled with improper medical treatment. One hundred New Jersey state troopers were deployed to quell the disturbance. The weather befitted the morose event, as it was wet and cold, and fog was draped over the X-shaped prison walls. Inside those walls, hundreds of prisoners ran uncontrolled throughout four wings of the facility, with fights breaking out among differing sects. Interior walls were destroyed, windows were broken, furniture was trashed and fires raged throughout the gray corridors. The revolting prisoners armed themselves with metal shanks, knives and Molotov cocktails, while troopers outside prepared to go in and retake control of the facility.

Jimmy Sparnroft remembers the event well and says he was the "only person" locked in his cell. "I would of killed that bastard [Biegenwald] that night. I could of gotten away with it…It was mass hysteria. People running all over the place like morons," he said. It would have been an opportune time to take action against the man Sparnroft held responsible for his incarceration. "They [speaking of his fellow prisoners] wouldn't let me out. They broke every lock on every door that night but mine." Sparnroft's friends knew he had been authorized for release on parole and was just waiting for the paperwork to go through.

It isn't known what Biegenwald's role was in this outbreak. However, there is no evidence to suggest he had any involvement in the outbreak and violent activities taking place in the prison. Perhaps his actions were an indication that he wanted to ensure his parole in the future by remaining neutral, or at least inactive, during the riot.

Chapter 7

The Light
Becomes Brighter

Dwight D. Eisenhower was president when Richard Biegenwald entered Trenton State, and sixteen years, two prisons and four presidents later, he became a free man. What would become of him, prison officials had to wonder. Was he reformed? Could he exist on the outside? These questions had to be asked by the parole board. While in prison, Biegenwald proved he had a reliable work ethic, whether as a printer, machinist or dental assistant. He worked hard and required little motivation. As for his diagnosis of schizophrenia, there appears to be no evidence to suggest that Biegenwald was under medical care for this illness while behind bars. Nor is there any recollection by those who knew him that he was taking schizophrenia medication, which had been readily available to manage the disease since the mid-1950s. Possibly, as Biegenwald's attorney Allen Kraut had suggested during sentencing, proper rehabilitation was once again not provided. There is no indication to suggest otherwise. Nonetheless, the parole board did evaluate his medical condition and his behavior while behind bars and determined that Biegenwald should be given a chance.

All parolees are given a parole officer to whom they are to report, mostly on a weekly basis. As is too often the case, these officers are not highly trained, and many don't serve as pillars of guidance and advice; rather, they're authoritative figures keeping a watchful eye. In Richard Biegenwald's case, the challenge was too great for anyone who didn't have a degree of training in the field of abnormal behavior and schizophrenia. And, as it turns out, even a deeper understanding of these problems wouldn't have helped. Biegenwald was deceptive and cunning and had an above-

average IQ, which in all likelihood would have placed him intellectually above the average parole officer. This, coupled with Biegenwald's ability to manipulate others, suggested that he would be a difficult assignment for a parole officer.

Tuesday, June 24, 1975, records Biegenwald as a free man living at his mother's house at 420 Sharrotts Road in Staten Island. He immediately was able to secure work painting houses and helping in several automobile shops on the island. Little is known of his activities for the first few years while on the outside. There are, however, a few snapshots available. Biegenwald had

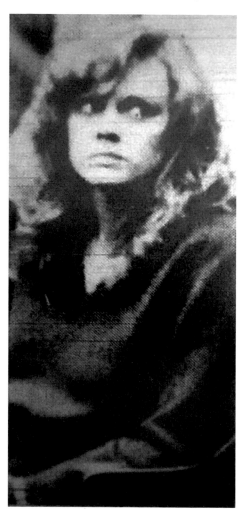

Diane Biegenwald. *Asbury Park newspaper photograph.*

aged considerably while behind bars. His bright red hair was losing its pigmentation, and he now sported a belly. His youthful stride had slowed a bit, and he was more mature intellectually than when he first entered prison. He had spent a considerable amount of time reading newspapers and magazines, as well as books in the prison library. Always articulate, he was now more mature and spoke more softly than before. His years behind bars had taught him to be controlled, deliberate and focused.

Once out, Biegenwald met a woman named Diane Merseles, almost twenty years his junior. At sixteen, Diane was already tall and pretty, with long blond hair and a slim, curvy figure. She was bright, friendly and a good student, having made the honor roll at Edison Senior High School in New Jersey. How they met isn't clear, but her interest in him was intense and sexual. There was something about the man that attracted women. And though he used recreational drugs to lure women into his grip, there

was more to it than that. His deportment was friendly, non-threatening and inviting. Something in the way he approached and talked to women put them at ease. Although never really handsome, his unique hair color and piercing blue eyes were appealing. It was evident in his use of the vernacular that he was bright, and many women probably assumed he was college educated. In addition, Diane saw a man who didn't live by anyone's standard; a man who was masculine, confident and a lone wolf—attributes that appealed to her and others as well. Their relationship apparently was sexually driven and likely perverse.

What we know about Diane is that after developing a relationship with Biegenwald, she never really achieved anything other than working odd jobs in entry-level, unskilled trades. Perhaps her aspirations vanished with their courtship. As time progressed, Diane became a fast user of an assortment of drugs, including prescription medication, which she would one day steal when she acquired a job in a pharmacy. She was permissive to his criminal activity; the degree to which she was aware is conjecture, but it's likely she knew the extent of his activities.

In 1977, Richard Biegenwald, driving down an isolated stretch of road near the West Shore Highway, picked up an attractive woman who was hitchhiking. The woman, greeted by a smiling face highlighted by bright blue eyes, got into the car and thanked the driver. She found him to be soft spoken and friendly, and they began a casual conversation. The talk was normal at first, but something within the confines of that automobile made the hair on the back of her neck stand up. Then, out of the blue, Biegenwald accosted her, but she slipped from his hold and ran from the car. The frightened women reported the incident to the police and gave a detailed description of her assailant.

It was determined that Richard Biegenwald was the suspect, and a warrant for attempted rape was issued, leading him to flee. He remained a fugitive until June 1980, when he was arrested at a party in Brooklyn, New York. Certain that he was going back to prison, he and Diane exchanged wedding vows behind the cold steel bars of a New York City cell—a place that to her may have seemed odd but was familiar to him. While he was in prison, Diane wrote long, sexually explicit letters fully describing what she would do to him.

After Biegenwald's arrest, the phone rang in a prominent Staten Island attorney's office. The voice on the other end asked the attorney to represent a young man accused of rape. That attorney was Lou Diamond; he knew not to ask too many questions and agreed to help. Diamond isn't a big man, standing only five feet, nine inches, with a few extra pounds around his

Lou Diamond. *Courtesy Kevin Quinn.*

waist, but nonetheless, he was a tough and respected criminal defense attorney who happened to live in the Biegenwald neighborhood. The name Diamond was shortened from a much longer Greek surname and was derived from the name of an old Jewish mentor of Diamond's grandfather. "My family was big on the docks," Diamond recalls. "My grandfather was a small man…weighing maybe 140 pounds. He would leave the dock weighing 180 pounds with sausages and meats stuffed under his coat… We were poor, with a lot of 'zeros.'" Lou Diamond was raised in Staten Island, which created a few challenges, as it was a rough neighborhood. Mob activity and crime were pervasive in the city throughout his youth. "My grandfather was a bookmaker…and lived to be of an old age and kept the book and that's why [I] didn't go into that business," Diamond jokes. Lou Diamond's godfather was the famed mobster John "Johnny Dee" Dalessio. Dalessio and his three brothers ran the illegal gambling ring on the island and were connected to the Gambino crime family.

Lou grew up to be a tough but bright kid. "I was the first person to graduate high school," he says, and thinking his best chance for college was "through sports," he participated in six different sports. He became a prizefighter and martial arts practitioner who "put [himself] through law school by being a bouncer and by working for Tommy Bilotti." Bilotti, a known Gambino crime family member, would one day rise to be an underboss, albeit short lived. He and Paul Castellano were gunned down in a plot devised by famed New York City gangster John Gotti. After graduating law school, "I got a very big case… [and] won it and kept on winning. Many people said these cases couldn't be won, but I kept on winning them. I had absolutely no connections. If you weren't connected, you had nothing. I had a pair of balls and the desire you had to kill me to beat me." It was Paul Castellano who noticed the up-and-coming lawyer. "Paul took a liking to me," Diamond says, and soon he was representing famous names from some of the underworld's most notorious

families. According to Diamond, it was someone in this group who called and asked if he could represent Richard Biegenwald, whom he was told "wouldn't give anyone up."

Diamond's godfather, John Dalessio, and three of his five brothers, along with Alexander (Pope Dee) and Michael (Mikey Dee), ran the illegal gambling network in Staten Island. John Dalessio—or Johnny Dee, as he was known by the locals— had a criminal record going back to the early 1930s, when he was first arrested, along with his brother Mikey Dee, for beating a man. Johnny Dee's uncle Alex DiBrizzi supposedly controlled the Staten Island waterfront as head of the local 920 International Longshoremen's Association. The criminal element in Staten Island was vast and had ties to traditional mob families. It is reported that Mikey Dee was a high-ranking official known as the *caporegime*, which is often shortened into "capo" for the Gambino crime family. Racketeering, extortion and loan sharking are some of the traditional crimes these families are involved in. It would not be a stretch to imagine a young Staten Island man straight out of prison, with no education or trade skills, being recruited into this network. Richard Biegenwald certainly had a skill they would want and would try to exploit he had no emotions and could kill without an ounce of remorse. And according to the voice on the other end of the line, he was loyal and kept his mouth shut. It was clear someone in the mob community wanted to see the kid get proper legal representation.

At the local precinct on the south side of the island, Diamond met his new client, and it was an experience he would never forget. Diamond walked into the back of the small station and saw his client sitting calmly behind the gray bars of a jail cell. The officer guarding the prisoner opened the cell door and allowed the attorney to step in. As he began to introduce himself, Diamond heard the cell door slamming shut and the key turning in the lock. While sitting in the cell with the man, Diamond noticed that Biegenwald had "an odd-color hair combination." There, against the cold concrete cinder blocks, the two got to know each other, talking for some time. Biegenwald explained to him about the shootout he'd had with the Maryland trooper. He "was very articulate and vivid," and he painted a visual for Diamond. He told of the snow falling and the feel he'd had, describing it as "surreal," Diamond says. "These are not words I'm used to hearing from a jail cell...Biegenwald was a brilliant man." The two then spoke of the charges against him and the event itself. "I knew there was something else there," recalls the attorney. "But I was also smart enough not to ask." Diamond stood up, summoned the jail guard and exited the cell, but not before looking back and saying, "You

have an odd hair color." And in the same breath he added, "We might be doing a lineup tomorrow." The hard metal cell door closed, and Biegenwald knew exactly what his attorney was intimating.

The following morning, authorities woke Biegenwald and allowed him to shower and shave before his hearing. When he emerged, he had shaved his hair completely off. The judge and district attorney were livid and called Diamond before them. Diamond said he was simply guilty of telling the man he felt his hair color was odd. It was a brilliant move on Diamond's part and also highlights Biegenwald's ability to grasp what his attorney wanted him to do.

The prisoner's shaving of his head created a quandary for the prosecutor. How could they proceed with the suspect lineup? "The judge and the DA were both Italians from the same neighborhood in Staten Island," says Diamond. "I said let's go get red wigs for everyone in the lineup. The judge said, 'What are we looking for, Ronald McDonald?' I then said OK, let's get goobalinis. The DA said, 'What's a goobalini?' The judge said, 'You're from [Staten Island] and you don't know what a goobalini is?'" (A goobalini is a wool hat commonly worn by sailors or seamen.)

Hours later, a lineup was arranged, with Diamond insisting that one of the participants be a police officer he noticed had similar eyes to Biegenwald's. The victim was brought into a dark room, where she was greeted by the judge, the district attorney and Lou Diamond. Standing together, they looked through a two-way mirror and watched as the suspects were escorted into the room and placed against the wall. All had dark wool hats over their heads, shielding their hair color. Diamond says of the incident, "Biegenwald doesn't get picked, and he walks." Looking back on the hitchhiker incident, Diamond says, "They thought he picked the girl up for purposes of sex. I think we all know now what he really had on his mind based on his record."

Chapter 8

Cold Case

I t was a crystal-clear day with bright blue skies and hardly a cloud to be seen as two local boys played in a wooded lot just off Highway 35. It was Friday, January 14, 1983, and the area the kids were playing in was directly off Sunset Avenue in Ocean Township, Monmouth County, adjacent to a Burger King restaurant. The parcel of land was about 230 feet by 220 feet in size and was dense with vegetation. The lot had been sitting vacant for years, and trees as large as 20 feet high and thick brush surrounded by weeds filled the area. In summer, it was nearly impossible to see through to the other side, but this was mid-January, and most of the vegetation had thinned. The kids were dressed warm—the temperature was lingering just above freezing—as they played their imaginary games. Then one of them spotted something that would be etched in their minds forever. The two ran home and told their parents what they had found. Soon, the wooded playground had become a crime scene.

The police arrived on the scene and followed a cleared path that was used as a trail to cut through the property. The body was discovered about fifty feet from the start of the path and lay just off the trail. The responding cops knew they had to cordon off the area and called the detectives to process the scene. It was an unusual location to drop a body due to the proximity to the Burger King, which was adjacent to the lot, and Sunset Avenue and State Highway 35, which surrounded the lot. As scores of police officers slowly surrounded the area, traffic on Sunset Avenue began to slow to a crawl as onlookers wondered what was going on. People from the Burger King

restaurant began standing in the lot and peering over to see the commotion. The yellow "Police Crime Scene" tape was brought out and soon was visible to traffic from both major roadways.

Years later, Ocean Township detective Robert "Bobby" Miller remembers the day all too well: "I can see that as plain as day; like I'm standing there right now. That shit you have to live with." What he saw were the skeletal remains of a female who was wearing a black shirt, blue jeans and no shoes. Miller was a seasoned cop and says, "I was going to save the world, and boy did I get a rude awakening." Standing six feet tall and weighing a solid 195 pounds, Miller had dark curly hair and brown eyes. He was local to the area, having been raised in Ocean Township, and he went to the Asbury Park High School nearby. Prior to becoming a cop, Miller had "knocked around quite a bit" and was not sure what he wanted to do for a career. After working several jobs, mostly in construction, he started as a postman but took the police test and passed. Working since 1968 as an Ocean Township cop, his first five years were spent patrolling the streets. Miller's first years were spent working rotating

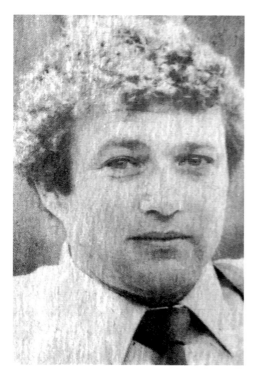

shifts, which provided him insight into the happenings in his venue both day and night. Miller had written tickets, investigated motor vehicle accidents and performed community caretaking services, many of which were mundane tasks. Nonetheless, he honed his skills and learned the ins and outs of policing. Through hard work and perseverance, he landed a position with the Detective Bureau. Speaking of the bureau, he says, "We did everything from stolen bicycles to murders, whatever came up." Walking down that path, he knew this case was the latter.

The Monmouth County Prosecutor's Office was notified and sent Detective Billy Lucia to investigate. Lucia was a longtime Monmouth County resident. Lucia is a cop with an interesting

Detective Robert Miller. *Asbury Park newspaper photograph.*

background and is very much part of the Asbury Park setting. He became a musician, playing mostly the saxophone. Together, he and a group of friends formed a band called the Jaywalkers—which is ironic, since the word refers a violation of the law, something he would one day stand against. The band was composed of John Shaw on drums, Mickey Holiday on organ, Lucia on sax and Billy Ryan playing the guitar. The Jaywalkers became a popular local group and even went into a local studio and released two songs, "It's Been Too Long" and "Olive Oil," for Wisteria Records. The songs were strong tunes and fused with the "Jersey Shore sound." After high school, many of his friends were cops who used to come into the local Asbury Park bar and listen to him and his band play, but he didn't feel their influence until a few years later. As a musician in the music business, Lucia says it was "too liberal" of an environment for his liking. Expounding further, he adds, "You either make it big or you're a bomb." During his time playing music, his nickname was "Cherry Bomb." His musical impact was worthy enough to have his name on the same plaque as Bruce Springsteen and other notable acts from Asbury Park, New Jersey. Today, this plaque is prominently displayed near the famous Stone Pony venue. However, music was not the avenue Lucia wanted to take. He married his sweetheart, Josephine, whom he calls "Cookie," at the early age of twenty-three and needed some certainty in his life. That certainty came in the form of policing.

Beginning with the Monmouth Beach Police. The Jersey Shore is a popular tourist attraction, and in the summer, departments such as Monmouth Beach have their hands full. Lucia parlayed this position into the much larger Ocean Township Police Department in 1973. Always ambitious and eager to learn, he was offered the opportunity he wanted. After a year or so, he moved part time into the detective bureau and eventually turned the position into a permanent one. Lucia was a good cop and looked the part, standing six feet tall with a stocky build. He had brown curly hair and brown eyes, with an olive complexion derived from his Italian roots. In January 1981, Lucia was asked by the Monmouth County prosecutor, Alexander (Al) Lehrer, to come over to his office. Lucia had just been promoted to sergeant and felt an allegiance to Ocean Township, but he had to consider what was best for him and his family. "I was not happy about that move," he says. But after much deliberation, he decided to take the chance and began with the county's Major Crimes Unit. It was that decision that placed him as lead investigator on the most notable case of his career.

Billy Lucia and Bobby Miller were colleagues on Ocean Township for years, policing the eleven-square-mile town nestled in Monmouth County. Ocean Township is considered part of the shore area, with residents made

up of mainly blue-collar workers. The township was experiencing a high crime rate, including robbery, rape and aggravated assault, which had been going on for a number of years. Since it is a shore community, crime has always increased with the summer influx. The community doesn't enjoy oceanfront views like the towns of Long Branch and Deal, which sit to the east; however, it remains a busy community nonetheless, with the major roadways of Route 18 and State Highway 35 cutting through the town, bringing people to Neptune and Asbury Park.

Driving to the abandoned lot in his unmarked vehicle, Billy Lucia could see cars sporadically spread in and around the area. Uniformed officers were positioned on all sides of the property, and many had their hands in their pockets to fight off the cold from the brisk ocean air. A few cops were seen talking, and the steam from their breaths filled the air as they conversed. Lucia stepped out of his car and was met by Bobby Miller; they immediately got to work processing the area while waiting for forensics and crime scene investigators to arrive.

The crime scene was properly documented with a series of pictures, and afterward, forensic investigators examined the skeletal remains. It

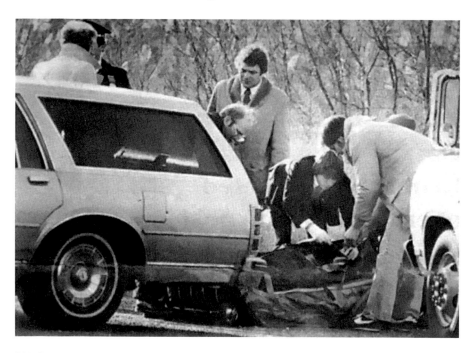

Billy Lucia watches as Anna Olesiewicz's body is placed into a car. *Asbury Park newspaper photograph.*

was quickly determined that the victim was female, wearing a dark shirt and blue jeans. What tissue matter was left on the remains was insufficient to determine alcohol or drug content. And even to the less tenured investigators, it was evident that the victim had been shot, as obvious bullet holes were present in the skull. Four holes were discovered, with three of the bullets still lodged in the skull. Investigators went through the lot with a fine-toothed comb to ensure that not a trace of evidence was left behind. Despite this, little evidence was recovered. Based on where the body was found and the rate of decomposition, it was thought the crime had occurred during the summer months. Also, though the lot was thickly overgrown during the summer, the area was still busy during the day, so police speculated that the body had been dropped during the wee hours of the morning when there was no activity in the area.

Anna Marie Olesiewicz

The sun had set and the sky had darkened over that parcel of land by the time Bobby Miller and Billy Lucia headed home. The thought of that young victim weighed heavily on their minds. Seeing a dead body never gets easier for a cop to handle—the images gather together like pictures in a photo album. When they got home, they couldn't stop wondering who she was and what had happened.

The following morning, the sun began to rise over the dark waters of the Atlantic, and people could be seen walking the famous Asbury Park boardwalk. Up early this morning was Mike Dowling, who was taking a brisk walk to the local store for a newspaper. It was his day off, and a cup of coffee and reading the paper were the only items on his to-do list. Dowling, an Asbury Park police officer, liked to relax in the morning after the rigors of the job the night before. Back at this place, sipping on his hot coffee, Dowling noticed a story of a body discovered the day before. Even though it was his day off, he often combed the papers to see what was going on in nearby towns. When he read about the victim and the paper's description of her clothing and bare feet, Dowling knew right away who she was. Mike Dowling was no ordinary cop, and Asbury Park was no ordinary town.

Asbury Park has been a tourist destination, with thousands of sunbathers and music lovers visiting each summer, for more than a century. Most people are familiar with the community because of Bruce Springsteen. However, many up-and-coming rock stars played at the famous Stone Pony restaurant, which sits on the boardwalk. Bon Jovi, Southside Johnny, Patti Smith, the

Ramones and Gary U.S. Bonds are just a few who played to this small venue packed with sun-soaked vacationers. Their music is often defined as the "Jersey Shore sound." Dowling had been patrolling the city streets here since the early 1970s and knew there was more to Asbury Park than sunbathers and music.

And although Asbury Park, New Jersey, is known to the modern generation as the place where Springsteen got his start, highlighted by his famous album *Greetings from Asbury Park*, it has a history that runs much deeper, dating back to the 1870s. The town was named in honor of Bishop Francis Asbury by James A. Bradley, a New York brush manufacturer who is the architect of the town. The homes and buildings in Asbury Park are constructed of Victorian design, and many wealthy people began to build houses here. Bradley designed a boardwalk and pier with public changing rooms for day-trippers and an orchestra pavilion. A decade later, a merry-go-round was built and became the first of many attractions that would grace the waterfront and become known as the Palace Amusement Complex.

As the century turned and decades passed, Asbury Park attracted grand hotels and theaters such as the Paramount and the Mayfair, as well as a large casino that sat on the pier, making the community a cultural hot spot for the wealthy. The boardwalk was filled with rich men in tuxedos strolling hand in hand with ladies dressed in fine gowns. Famous people began to come and entertain the elite, including Frank Sinatra. Fine shops filled the streets with jewelry and expensive clothing. Jazz and music clubs were popular in town and provided a cultural mix for residents and visitors. Exquisite restaurants were ample, with finely dressed patrons visiting them nightly. Then, with the construction of the Garden State Parkway in the late 1940s, people who couldn't normally afford to travel to Asbury Park began to visit. As time went on, large hotels and theaters began to close due to a lack of cultural interest as the wealthy began to move out for other towns that were developing in South Jersey, including Atlantic City. By the 1970s, Asbury Park was not the town it had once been, and theaters, shops and restaurants began to close and become vacant buildings. When Mike Dowling says, "I walked the beat in a high crime area in a high crime time," he isn't exaggerating. The empty buildings became refuges for the homeless and drug pushers. Street walkers roamed the town offering sex for money, and drug users came into town to get their fix. Those now interested in Asbury Park, besides the "Johns" and drug users, were teenagers and musical groupies who enjoyed the boardwalk bands.

Mike Dowling had served two tours in Vietnam as a marine, going back a second time of his own accord. It took some time for the Asbury Park cop to

decide what he wanted in life. "I kicked around for a couple of years," says Dowling. It wasn't until September 1973 that he put on a badge. Most of his early tours were at night, and even so, he enjoyed the work. After five years as a flatfoot, he moved to the K-9 unit to help eradicate the drug problem in the shore communities. In the winter of 1981, Dowling became a detective and spent the next several months learning this new position.

By the summer of 1982, Dowling was still learning the ropes as a detective, and the upcoming summer was sure to keep him busy. Local taverns and bars on the boardwalk were increasing their food and liquor supplies in anticipation of the summer season. Bruce Springsteen had started his "Bar Tour" earlier in the year, and by August, he had performed twice at the Stone Pony with the popular local band Cats On a Smooth Surface. Township workers were cleaning the sandy beaches, and beach patrols were interviewing for new lifeguards. Police departments along the shore were hiring auxiliary officers to help with the influx of people that the sunny weather would bring. Many small businesses that close during the winter months were now opening their doors and getting ready for what was hoped would be a busy summer.

The two songs carried most by the sea breeze this summer were the songs "Eye of the Tiger" by Survivor and Olivia Newton John's "Physical." It was a time when *Dallas*, staring Larry Hagman, was the number one show on TV, and the shows *Three's Company, Joannie Loves Chachi* and *The Jeffersons* filled the small TV screens. President Ronald Reagan was leading the country and was still recovering from his gunshot wounds from the assassination attempt on his life.

Since the first nice days in May, musicians began appearing on the boardwalk with bigger acts playing at the Convention Hall in Asbury Park. Elvis Costello's concert took place the Tuesday before Anna Marie Olesiewicz's arrival into town.

It was the case of Anna Marie that weighed heavily on Mike Dowling's mind. She simply disappeared, and he had no clue what happened. Dowling, a bright and talented cop—and probably the only police officer at the time with an accounting degree—believes his education helped him as a detective. "The same type of logic to analyze numbers is used when trying to analyze a crime scene," he says. It is with this analytical mind that Dowling quickly put together the connection of the barefoot body with Anna's case. He remembered that Anna's friend went home to use the restroom and had Anna's shoes in her pocketbook. When the friend returned to the boardwalk, Anna was gone.

IT WAS THE EVENING of Friday, August 27, 1982, when Anna Marie Olesiewicz and Denise Hunter drove to Neptune City to spend the weekend at the shore. Their plans were to sunbathe, listen to music and party. Both girls were eighteen and eager to get to the beach. Anna was an attractive girl with long black hair, dark eyes and a slender build; she stood five feet, six inches tall. Her father, Robert, was a Camden firefighter who had raised her on his own since the age of nine, when her mother—whom she was named after—passed away. She and her father lived on Morton Street in Camden. Anna's friend Denise was equally attractive, and Denise's uncle had a shore house in Neptune City, which was a stone's throw from the Asbury Park boardwalk.

After visiting several places that night, the girls sat on a bench across from the Stone Pony and listened to the music coming from inside the restaurant. It was about midnight, and Anna's feet hurt, so she took off her shoes and put them in Denise's pocketbook. Denise needed to go to the bathroom but didn't want to use the dirty ones close by, so she decided to walk to her uncle's house. Anna said she would wait until Denise returned, and Denise hurried off, turning one last time to look at her friend sitting there in the dark. Off in the distance, no more than fifteen feet or so away, stood Richard Biegenwald. He was watching Anna's long black hair blow softly in the cool sea breeze. She was the type of woman he was attracted to—young, dark hair, dark eyes and slender. No one is really sure what happened that night, but it's likely that after several minutes, Biegenwald noticed Anna's friend had not returned and walked over to her. His unassuming demeanor and piercing blue eyes presumably posed no threat to the woman. He was friendly and articulate and asked her if she wanted to smoke pot. It's believed that they smoked a joint, and then

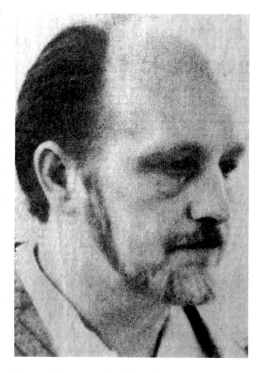

Richard Biegenwald. *Asbury Park newspaper photograph.*

Biegenwald told Anna he had more at his house, which was only two minutes away. As they walked to his car, Anna's fate was sealed.

When Denise returned, Anna was gone; thinking her friend had gone into a bar, Denise checked several places. Afterward, she returned to her uncle's house, hoping Anna was there. She was not. Denise went to bed and assumed Anna would return sometime in the night.

In the morning, the sun lightened her dark room and woke Denise from her sleep. Exhausted from staying up late, she was barely able to get out of bed. She went to wake Anna to find out what had happened to her and discovered she was not there. It was clear she hadn't come home. Alarmed, Denise rushed to the police station and reported Anna missing.

Mike Dowling was at the station when Denise reported the incident. He spoke with the distraught friend and gleaned as much information as he could from her about the prior night's events. Denise Hunter told of their drinking and going to the bars throughout much of the night, as well as the last location where she saw her friend. With this information in hand, Dowling hopped into his unmarked car and visited several establishments on the boardwalk. Walking from tavern to tavern, the sun sat high in the sky, and he could hear the waves pounding the shore. He was unable to find anyone who had seen the missing teenager; it seemed as if she had vanished. Once he determined the girl had gone missing, Dowling interviewed Anna's father and friends. Robert Olesiewicz was beside himself. He had lost his wife, and now his precious little girl was missing. It was a difficult assignment for Dowling, but one that is crucial in missing person's cases. Often, when criminality is involved in these cases, it is someone with whom the victim was familiar who committed the act. The case went cold fast, and what had happened to the girl remained a mystery.

WHEN DOWLING CALLED THE Ocean Township police and said he believed he knew who the victim was, they were skeptical. However, after hearing the seasoned cop explain his rationale, the authorities contacted the Olesiewicz family and asked for dental records. The heartache triggered by this call can only be imagined. Robert had not given up hope that his daughter was alive. Sadly, the dental records confirmed what Mike Dowling already knew.

"I can remember Bobby and I going to Camden," Lucia recalled. Questions needed to be asked of family and friends. In a case like this, everyone is a suspect, including Denise Hunter, who was the last person to see the victim alive. Lucia and Miller interviewed Hunter and her boyfriend—a guy peopled called "Noblock." Both cops were suspicious of Hunter and

her reasons for leaving Anna alone at the boardwalk. Considered a "person with some issues," Hunter's insistence that she had gone home to use the bathroom seemed sketchy. However, when her room was searched, bags of vomit were found, and it was revealed that Hunter was bulimic. This was the reason she had wanted to go home to use her bathroom. Hunter and Noblock were given lie detector tests and were quickly taken off the suspect list. Lucia and Miller also learned that Anna had been wearing a black and gold ring. However, there was no sign of the ring at the crime scene. The ring, which initially appeared to be inconsequential, would prove to be a key piece in this case. After spending an entire day in the city of Camden speaking with family and friends of the victim, Lucia and Miller believed they had nothing to hang their hats on.

Chapter 10

Key Witness

Theresa Smith was a twenty-two-year-old beauty with dark curly hair, brown eyes and facial features that turned heads. Her one flaw was an addiction to amphetamines, often called speed. While working as a waitress, she met Diane Biegenwald, and the two became friendly. Diane herself was no stranger to drugs, nor was her husband. It is this interest that brought the three together. An attachment of sorts was formed among Theresa, Diane and Richard—one that is hard to define due to conflicting accounts. Some believe a sexual relationship between Diane and Theresa existed; others speak of a ménage à trois fling, and some suggest a twisted sexual relationship between Theresa and Biegenwald, consisting solely of anal sex. Nonetheless, whatever type of relationship it was, we can gather it was not your typical landlord-tenant arrangement.

From June to October 1982, the three shared an apartment at 507 Sixth Avenue in Asbury Park, and during Theresa's stay, events occurred that weighed heavily on her mind. The cause of her leaving isn't known, but perhaps it was the pressure Biegenwald put on her to participate in his "thrill killings." After she moved out, she began dating a man named George Susco, who was estranged from his wife. Susco was an average-looking man with blond hair and a soft-spoken voice who was much different than Biegenwald. And although he and his wife were separated, Susco remained friendly with her, and the two often talked. By the second week of January 1983—just as the papers reported the discovery of Anna Olesiewicz's body—Theresa and George had just returned from a cruise. Seeing the news of the skeletal remains sent Theresa into a frenzy

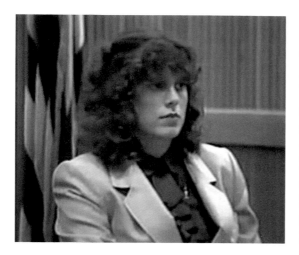

Theresa Smith. *Courtesy Kevin Quinn.*

of anxiety and fear. She could no longer keep inside what she had witnessed and had an emotional breakdown. Theresa had spoken to George of things she had seen while staying with the Biegenwalds, but he presumably wrote it off as her drug-induced imagination. He shared some of these stories with his ex-wife, Bonny, who was a probation officer, and she, too, believed the stories were embellishments at best. Theresa said Biegenwald had killed the girl, and she saw her lifeless body in his garage.

George had Theresa speak with his wife, and what the probation officer heard sent chills down her spine. She couldn't sleep that night and picked up the phone to call her friend Bobby Miller. Miller and his wife were fast asleep when the phone rang. "I know who killed that girl," the voice on the phone said. Miller had to think a moment and wipe the cobwebs from his head.

"What?" he asked.

Bonny explained that she had a witness to the crime. "I asked if she would talk with me," said Miller, and Bonny responded, "Probably would, but she's really scared to death."

Later that morning, Bonny set up a meeting in an open and public place with plenty of people around, as specified by Theresa. The meeting would take place at the Monmouth County Mall in a jewelry store there.

The mall is a large indoor and outdoor shopping center located in Eatontown, where thousands of people shop weekly. Miller arrived at 10:00 a.m. and noticed that the lots were already quite full. He saw Bonny waiting for him. Together they walked inside to meet Theresa, who was waiting. Looking at the woman standing there white as a ghost, Miller introduced himself. Her voice was sweet but crackled as she spoke, and she nervously scanned back and forth to see who was watching. If she wanted to be inconspicuous, she wasn't helping her case. "We had to go to the JC Penny store to talk. She was afraid to speak in the open, so we went over to the

curtain section, where we would be concealed by the curtain display," recalled Miller. There, between the curtains, Theresa told her tale of dead bodies, drugs, guns and even bombs. "What she said would make your hair stand up," Miller said. Hearing her talk, he, too, began to look around. This was not the place for them to be speaking. "I convinced her it would be in her best interest to come in and give us a statement."

Bobby called the prosecutor's office and spoke with Billy Lucia, who couldn't believe what he was hearing. The two decided to act immediately, and an interview was arranged for later that afternoon at the Ocean Township Police Department.

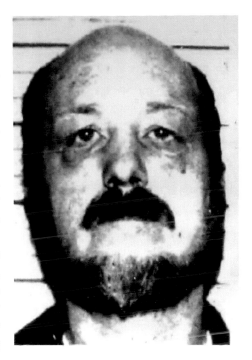

Mug shot of Richard Biegenwald, circa 1980. *Asbury Park newspaper photograph.*

The date was Friday, January 21, when Bobby Miller and Billy Lucia sat down and waited for Theresa Smith to arrive. The headquarters is a beautiful brick struck with white-trimmed windows and the words "Township of Ocean, POLICE" in big black letters proudly displayed on the exterior. Theresa pulled into the parking lot and was brought down the cold, bright hallway to the interview room. Although in a police station with armed police officers around, Theresa seemed more nervous than before. The interview room was nondescript; it was where detectives honed their interview skills day after day. This was a cooperative interview and took on a conversational tone, with Lucia and Miller helping stimulate the conversation and to fill in the gaps with specific questions. "She was calm and forthright," recalls Miller. All the pent-up emotion was now coming out, and Theresa spoke of her sex life with Biegenwald. Miller remembered her saying that "he [Biegenwald] was screwing her anally." This was the part of the interview where she needed to be guided and kept on track with what they really wanted to hear.

According to Theresa, it all began when she was working in a jewelry store and met Diane Biegenwald. Diane was a co-worker, and the two hit

it off, causing Diane to ask her to move in with them at their Asbury Park apartment. The co-occupancy began sometime in June 1982, and it wasn't long before Theresa entered into a sexual relationship with Biegenwald. Sometime thereafter, Diane began working in a local hospital, where she stole drugs for the three of them. Over time, Biegenwald began teaching Theresa how to shoot a gun and often took her to the woods for target practice. In their talks, he told her how he preferred a small, .22-caliber handgun because "the bullet would go in and rattle around the brain." Smith told the two detectives that Richard Biegenwald had killed before and did a number of years in prison. In prison, she said he met Dherran Fitzgerald, a self-proclaimed "hit man" who was now living in the apartment across from Biegenwald's. She said Fitzgerald carried a gun wherever he went and had several at his place. Because Biegenwald did not have direct access to the basement of the building, he cut a hole in the floor and built a stairway leading to it. Fitzgerald's apartment had direct access, and the two men would construct weapons and bombs down in the dark recesses of the basement. The apartment was located at 507 Sixth Avenue—a large old shore home that had been converted into a series of low-income apartments. Smith also spoke of a hidden room in Fitzgerald's apartment that was used to grow marijuana and house at least one weapon. The room had a two-way mirror that allowed Fitzgerald to see out, but others could see only their reflections.

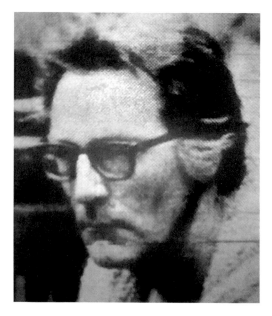

Dherran Fitzgerald. *Asbury Park newspaper photograph.*

The two detectives sat in shock at what they were hearing, but Smith was just getting started. "She was scared," says Billy Lucia. "She didn't want to tell what had happened because of him but knew what would happen if she didn't." She paused momentarily to drink some water, then cleared her throat and continued. Theresa said Biegenwald often acted like a women experiencing PMS and then would leave—sometimes

for hours, sometimes for days. When he returned, he was relaxed and calm. What he did to relive his stress was kill. It wasn't a sexual thing, Theresa thought. It was about the thrill. Something about killing a woman gave Richard Biegenwald a deep thrill. "Smith described how [Biegenwald] would go out…wearing a black leather vest, similar to a motorcycle rider with a black cap," said Miller. "He would go to the boardwalk and hang out and ask the girls if they wanted to hang out and smoke weed." Theresa said she was aware of his behavior because Biegenwald was trying to get her to help him in his "thrill killings." She said he wanted her to become his "protégé." He wanted her to prove she was "tough." After weeks of grooming her, Biegenwald felt she was ready to kill, and together they plotted the murder of Theresa's co-worker, a girl named Betsy.

On the evening of Friday, August 27—the night Anna Olesiewicz disappeared—Theresa was supposed to have killed her co-worker. Under the guise of a friendly night out with Betsy, the two drove around the shore area as Theresa tried to muster up enough nerve to kill. However, Theresa was unable to go through with it and drove the unsuspecting Betsy home. When Biegenwald found this out, he was infuriated. He stormed off, and Theresa went to bed. Later that night, she was awakened by Biegenwald bending over her bed. He wanted to show her something, but she was tired and refused to get up. After he left, she peered out the window and saw what she described as the "shadow of a body" in the passenger seat of Biegenwald's car. She thought nothing about it and went back to her drug-induced sleep. The following

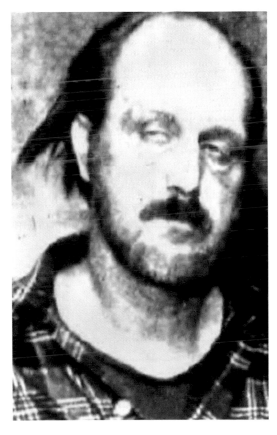

Richard Biegenwald. Daily Register *photograph.*

afternoon, Biegenwald wanted to show her something in the garage. Entering the small, detached garage that sat on the back corner of the property, Theresa observed an old mattress on the floor. Biegenwald lifted the mattress to reveal the body of a young women with her head wrapped in a green garbage bag. Theresa could see the girl was wearing unzipped jeans and a dark shirt and was barefoot. Theresa said Biegenwald wanted her to "touch the body…and 'pick her leg up' and tell him how it felt." Then, there in the cold concrete garage, he told her how he had met the girl on the boardwalk and lured her away with marijuana. He brought her home because he wanted Theresa to kill her. However, when she refused to get out of bed, he shot the girl himself. After telling Theresa this, Biegenwald bent down and removed a gold and black ring from his victim and gave it to her. About a month or so later, Theresa gave the ring to Diane.

Theresa Smith went on to tell the detectives that inside both apartments and in the basement was an arsenal of weapons—bombs, explosive devices and a poisonous snake from which Fitzgerald and Biegenwald were extracting venom. She said the two had a diabolical plot to poison people at the Monmouth County Mall. When the interview concluded more than an hour and a half later, Billy Lucia and Bobby Miller were beside themselves trying to digest what they had heard.

Chapter 11

The Takedown

Lucia left the room and ran to call the prosecutor's office to report what he had just heard. The prosecutor was Alexander Lehrer, to whom many referred as "Hollywood Al" because he liked to grab the media's attention in high-profile cases. At thirty-eight years old, Lehrer was a stern, sandy brown–haired man with light-colored eyes and a slender build. He was an ambitious man who liked to let people know what his office was doing and used the press like a professional. Alexander Lehrer grew up at the Jersey Shore and resided in the small community of Wall with his wife and daughter. He was not a handsome man, but he was not unattractive either. His average looks were outweighed by his exceptional talent and skill. His firm prosecutorial approach was embraced by the community. He was a graduate of the University of Notre Dame Law School and was an astute politician. One of his favorite pastimes was playing the video game Pac Man, and on the way to work, while stopping for coffee at the local 7-Eleven, he could be seen standing in front of the video game. One of Lehrer's assistant prosecutors was equally as talented; his name was James Fagen, a small but tough Irishman with credentials no less impressive.

Born and raised in the city of Elizabeth, Fagen attended St. Benedict's School in Newark, where, as a small, light-haired kid, he roamed the urban community. He credits this upbringing with teaching him how to interact with different social and ethnic groups. Growing up on the city streets of Elizabeth, Fagen managed to steer clear of the bad crowd and maintained good grades in school. After graduating high school, Fagen attended Loyola University

in New Orleans for his undergraduate studies. Standing only five feet, seven inches, and weighing a lean 150 pounds, Fagen had blue eyes and blond hair, and like Al Lehrer, he was smart and ambitious. On a whim, he took the law school examination and was accepted. It was 1969, and the United States was embroiled in the Vietnam conflict. "I remember sitting in the dormitory, waiting to see if my lottery number for the draft came up," he recalls. Fortunately, it didn't, and he began his legal studies at Loyola University. Situated a stone's throw away from the Mississippi River, Loyola University is a Jesuit college with its roots going back to the early settlers of New Orleans. The gorgeous campus, with its red brick structures, provides a nice setting for young adults to study the many advanced programs offered at this prestigious university. A short streetcar ride away is the renowned Bourbon Street—a location perfect for those wishing to experience the unique culture of New Orleans. "There's no better place to go to school than New Orleans," says Fagen. It is also down in New Orleans where Fagen met his wife, Margaret.

The Asbury Park apartment. *Asbury Park newspaper photograph.*

She, too, would go to Loyola Law School and become an attorney. After they graduated, they headed to New Jersey to begin their legal careers, with Fagen working in the city of Bayonne for a small law firm.

It is here in Bayonne where Fagen learned his craft, much like Stephen Sladowski had done some twenty years prior. Fagen worked long, arduous hours, sometimes not getting home until ten o'clock at night. Once he and his wife had their first child, Fagen realized he wanted to spend more time with his family. "I wanted to get some order in my life," he says. The public sector offered health benefits and a more structured environment in which to raise a family, so in 1981, James Fagen applied and was appointed assistant prosecutor for the Monmouth County's prosecutor's office.

When the body was discovered in the vacant lot, Al Lehrer assigned James Fagen the case. After receiving the phone call from Billy Lucia, it was clear to Lehrer that the case was much larger than expected. Nonetheless, Lehrer had faith in James Fagen and kept him assigned to the case.

As an attorney and as an assistant prosecutor, Fagen demonstrated an intense dedication to the practice of law. Besides his family, his sole interest was his work. Strong and reserved, Fagen primarily keeps his personal views to himself and seldom shows his emotions to the outside world. Nonetheless, the case he was about to embark on would bother him immensely. And along the way, he would shed a few tears for the victims and the families he would come to know.

Fagen remembers speaking to Lucia and hearing what he had gleaned from his interview with the witness. "I had them verify who this man was…and if he [Biegenwald] was still living at the address," he says. Detectives gathered as much intelligence on Richard Biegenwald and Dherran Fitzgerald as they could muster. First up was to confirm if Biegenwald and Fitzgerald were still at the Asbury Park address. Then they needed to look into their criminal histories. As Theresa Smith had stated, Biegenwald had killed someone in cold blood in 1958 and served a long prison term. His record also showed his arrest and release for attempted rape and that he was returned to prison for violating his parole; no other records were found. Investigators learned that Biegenwald was working as superintendent at his Asbury Park apartment and was responsible for maintaining the facilities and collecting rent. Fitzgerald's record was more current, as he had been in and out of prison throughout his life, though he never served as long of a sentence as Biegenwald.

Dherran Fitzgerald was an interesting man of large stature, weighing over 230 pounds and standing between six feet, two inches and six feet, three, with a powerful build. He had a long face and forehead and sported light brown hair, which he wore on the long side. His face was lean with a stern look, punctuated

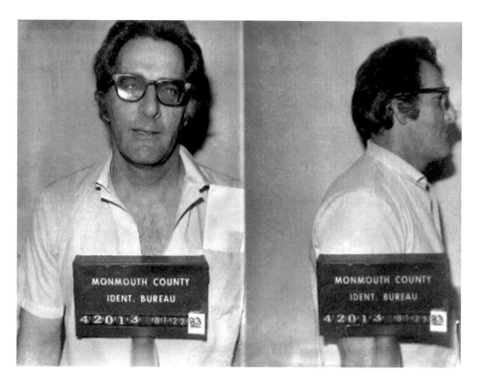

Dherran Fitzgerald's mug shot. Courtesy Kevin Quinn.

by his brown eyes. His vision was poor, and he wore thick eyeglasses. Born in October 1935 and raised in Long Island, New York, Fitzgerald had his first scrap with the law in 1952 at the age of seventeen, when he assaulted someone with a knife. A few years later, he was arrested for carrying a gun, and the outcome of this charge is unclear. Sometime in 1958, Fitzgerald entered the United States Navy and served as a paratrooper until 1962, when he was honorably discharged. From April 1963 to July 1965, he was a prisoner at both Sing Sing and Attica for attempted burglary. In September 1966, Fitzgerald robbed a housing project in Camden, New Jersey, taking a Camden police officer and two others hostage. After a brief standoff, he was arrested and found to be wearing a women's girdle stuffed with handguns. Fitzgerald had two known aliases: Al Wirtshafter and Al Kelly, both names to which he had credit cards issued. Fitzgerald waxed floors at local supermarkets and had recently been arrested for shoplifting at a local delicatessen. He failed to appear in court, and an outstanding warrant existed for his arrest.

The two men's backgrounds validated Theresa Smith's statements and suggested that apprehending them would be difficult and dangerous. At about

4:00 p.m., Billy Lucia and James Fagen drove over to the Ocean Township Police Department so Fagen could personally speak with Smith. As with anyone who first laid eyes on her, Fagen couldn't help notice how attractive she was. Then, as Theresa spoke, he could hear the truthfulness in her nervous voice. Her body language told Fagen she was frightened. After a brief talk, Fagen and Lucia sat at the typewriter and wrote an affidavit for a search warrant. "I drove to Judge Shebell's house in Middletown to get it signed," says Fagen. As Fagen turned into the magistrate's driveway, the sun had settled over the horizon. The porch light was on and cast a shadow behind him as he knocked on the door. That shadow was symbolic of the man Fagen was hoping to apprehend—Biegenwald had always operated in the shadows. However, Fagen was still unaware of the full scope of Biegenwald's horrors.

Judge Shebell was a congenial man and was also educated in the South, receiving his law degree from the University of Virginia School of Law. The two sat in the living room while Fagen explained the details of what he had learned.

With the warrant in hand, Fagen sped south on SH-35 to headquarters, where a contingent of detectives, officers and Hollywood Al Lehrer waited. A pre-raid plan was being put into place, and Fagen wanted to listen in to how they were going to conduct it. According to Lucia, a plan to hit the apartment "while minimizing the risk for a shootout" was being constructed. Considering the backgrounds of the two suspects, this may have been wishful thinking. Lucia said they "got in touch with Asbury Park Police" to assist; after all, the raid was to take place on their turf.

A team was put together that included evidence handling to be done by Kevin Quinn, an evidence preservation expert with Ocean Township. A tall, slender officer, he and Fagen could have been taken for brothers with their light hair and blue eyes (other than the height difference). Quinn, however, grew up on the sandy beaches of Asbury Park and used to work on the boardwalk during the summer as a kid. He was educated through the parochial school system and, after high school, worked a number of

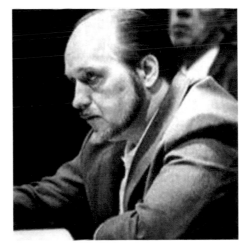

Note the dimple in the upper cheek from a bullet. *Asbury Park newspaper photograph.*

jobs at a local newspaper, a fresh air fund camp, a meat market and a grocery store and as a mechanic, an appliance repairman and a public works employee. Quinn was heavily influenced by the sights and sounds of Asbury Park and became a musician, playing the guitar. He would one day find himself on the boardwalk playing for the local crowds. However, music was not the path he would take professionally. It would be law enforcement, and in December 1977, he became an Ocean Township cop. A year later, he found himself working undercover. In 1981, he entered the detective bureau, which in turn, placed him as part of the team this night.

Gathered in the back offices of the police department were Bobby Miller, Billy Lucia, Mike Dowling, Kevin Quinn, Ken Kennedy and a contingent of uniformed and plain-clothed officers, as well as Fagen and Hollywood Al. It would be a gathering like no other. "They were trying to decide about the veracity of Theresa Smith," says Dowling. "She told a story that was just incredible. She said they had guns all over the house; they had cigarette lighters that were machined to fire a .22-caliber rifle round. There was a hidden room under a staircase." Most concerning to them was the poisonous snake Theresa called a "puff adderler," laughs Bobby Miller. The actually pronunciation is puff adder, which is a venomous viper species considered one of the most poisonous in the world. If Biegenwald and Fitzgerald were building explosives, creating makeshift guns and extracting venom from a snake, they could very well have the place booby-trapped. As the cops were huddled together in a small room, the questioned was posed: "How do we take them down?"

Some had suggested responding with a fire truck under the guise of investigating a gas leak, with residents needing to be evacuated. However, this involved the fire department and might put innocent people in harm's way. Finally, "we devised a plan of a prowler," says Billy Lucia. According to Fagen, they "figured if [Biegenwald] came out to see what was going on, we could snatch him off the porch…One cop posed as a burglar, and the other officer had him cuffed." The plan was to knock on the door under the guise of inquiring whether Biegenwald knew the prowler. All agreed this was a good idea. Ken Kennedy says, "They go, 'Who we gonna get to crawl though the yards?' At the time, I'm probably the youngest guy there, dressed in jeans and a jacket, and everyone looks at me. And I go, 'OK, OK.'"

Kennedy was a detective with Ocean Township and was no stranger to the case, as he had been instrumental in interviewing Denise Hunter, along with Mike Dowling, and retracing the steps Denise had taken the night of Anna's disappearance. At thirty-four, the six-foot, two-hundred-pounder with brown hair and green eyes was eager to play his role. Kennedy had

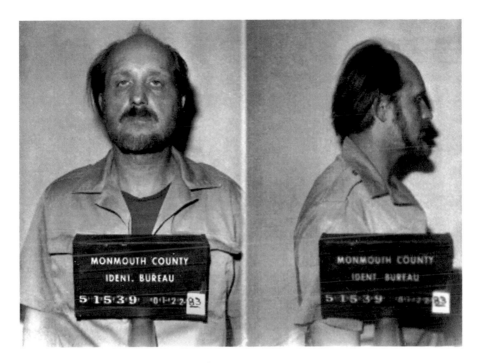

Biegenwald mug shot. *Courtesy Kevin Quinn.*

served four years in the navy working in submarines, so he was used to being confined. His interest in law enforcement had come the last year of his service while he was out in Maryland and met a few influential FBI agents. He had entertained the thought of being an FBI agent when he left the service and, to that end, attended college. He had joined the Ocean Township Police hoping to parlay the position into the federal agency. However, he says after doing police work, "that's where I wanted to stay."

The residence was a large house composed of four individual apartments. The back of the house was L-shaped from an addition that had been added to the original structure. There was a series of stairs that was used to gain access to each apartment through separate doors. Because of the individual apartment doors, it was believed they would be able to take Biegenwald into custody without Fitzgerald suspecting anything. Officers and detectives would take strategic positions, with some immediately outside Biegenwald's door. It was near midnight before all the details were worked out, and the coffee was flowing freely. The execution of the raid would take place in the wee hours of the night when the apartment's occupants were sure to be asleep.

Chapter 12

Long Night

With the plan set and the players picked, it was now a matter of waiting. Hollywood Al began to draft a press statement, while others waited pumped up on adrenalin and caffeine. There was the very real possibility that the night would not end peacefully, and the thought of Richard Biegenwald shooting it out with the two Maryland cops weighed heavily on the minds of many.

In the early morning hours of January 22, the team packed up its stuff and headed to the rendezvous location, which was just a block from Biegenwald's place, at 50 Seventy-sixth Avenue. The temperature had dipped to twenty-one degrees, and the cold ocean air burned their faces as they stood going over the plan one last time. To ensure that Biegenwald bought the prowler bait, Ken Kennedy was to crawl through the backyard and act like he was breaking into a car; then, a commotion would be made with the police arresting him. At 3:00 a.m., they were ready to go, and now it was just a matter of Kennedy getting into place.

The street was dark, with scattered exterior lights illuminating several residences with a dim glow on Biegenwald's porch. Kevin Quinn was hiding in the neighbor's yard, and James Fagen, Billy Lucia and others were scattered nearby in the bushes. Kennedy remembers crawling through an adjacent yard with Mike Dowling beside him. As they moved toward Biegenwald's apartment, what Kennedy saw gave him an eerie feeling. "The [Olesiewicz] family, exhausting everything they could to find Anna Maria," says Kennedy, "hired a psychic medium." The medium spoke of "an older

two-story green house in Asbury Park with a backyard, a white picket fence and an old man." The house was just as she described, including the white picket fence Kennedy had to climb over to enter the property. With Dowling staying near the property line, Kennedy went over to the car as if he were trying to break in. "Within a minute, I begin to hear, 'Hold it right there, get down, get down!' Then you can see the lights go on within the apartment. We heard the inner door open up." Diane Biegenwald was standing there with her husband by her side, watching the commotion. "Rich, come on you know me!" shouted Kennedy. "You know me!" Initially, Biegenwald didn't want to come outside and said, "Arrest him." But with Kennedy's insistence, Biegenwald stepped out. "True as thieves are," laughs James Fagen, "he says, 'No, no he's OK,'" and turns to go back inside. It is then that Biegenwald was tackled and put into handcuffs.

"He had that look of 'I'm fucked,'" said Kennedy. "He had that I'm fucked look on his face." He was quickly brought down the driveway to a waiting police car, and Diane was placed in a separate vehicle. "We wanted to move quickly to get Fitzgerald," says Kennedy. Describing Fitzgerald's door as facing the driveway, Kennedy said, "It is possible [Fitzgerald] saw us take Biegenwald down."

"I went over to [Fitzgerald's] apartment and knocked on the door," says Lucia. "This big, heavy-set girl [Jennifer Metz] answers the door. I told her I was there for Dherran Fitzgerald, and I needed to look for him. She said, '[You're] not coming in,' and I said, 'Yes I am, I have a search warrant.' I pushed my way through her, which was really not easy; she was a big girl," he laughs. After checking one room with his gun drawn, Lucia headed toward another that had an arch entrance. "I saw movement on my right," he says. "Thank God I had the presence of mind. It was a little kid on the couch." After clearing all the rooms, Fitzgerald was nowhere to be found. More than an hour or so went by, and Fitzgerald couldn't be found. Then, "sure enough, we went into Fitzgerald's apartment and there was a mirror," Fagen remembers. This had to be where the hidden room was, they thought, and started "pulling the mirror off the wall," Lucia says. "Sure enough, there was Fitzgerald with a rifle next to him." Fitzgerald had been watching the detectives for more than an hour with a gun next to him. "Fitz was very articulate," says Lucia. "He was concerned about the kid and knew there were other officers there. He knew the game." It would have been a losing proposition for him. When they took Fitzgerald out of the room, he had only boxer shorts on. Al Lehrer happened to be in the room, and Fitzgerald said to him, "Mr. Prosecutor, can I have my pants?" This was unsettling to

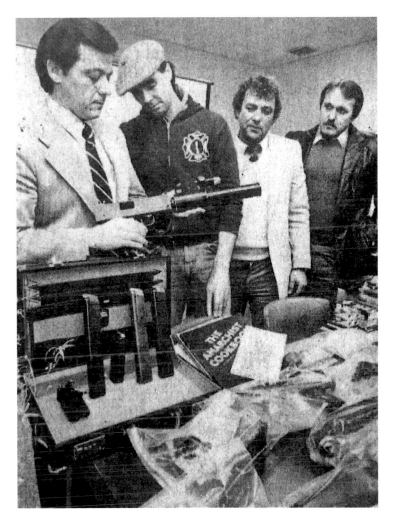

Billy Lucia, Mike Dowling, Bobby Miller and an unknown officer with recovered guns and ammo. *Asbury Park newspaper photograph.*

Lehrer that a self-professed hit man knew exactly who he was. "He was a serious bad guy, very smart," says Dowling of Fitzgerald. In Dowling's mind, Fitzgerald was "a notch up from Biegenwald."

The takedown was orchestrated perfectly, and fortunately, finding Fitzgerald worked out as well. Not a shot had been fired. Both apartments were filthy with old, worn-out furniture and litter thrown all over. The entire place was dark, with dim bulbs barely illuminating the space. Hollywood Al and James Fagen were amazed with what investigators were

finding; homemade bombs were all over the place, with some sitting on the fireplace mantel as if they were shelf ornaments. Cigarette lighters were found converted into .22-caliber weapons, one of which went off when an unsuspecting officer went to light his cigarette. Luckily, no one was hit. Then there was the fully loaded Mack 10 semiautomatic rifle in Biegenwald's room and a gun everywhere you looked in Fitzgerald's apartment. In the middle of Biegenwald's living room was a large hole in the floor that led to the basement. Mike Dowling was one of the first to go down. "It was creepy down there," he said. The place was completely dark except for a blue light in the distance. They noticed a makeshift bedroom adjacent to a work area where the light was coming from. As Dowling and the others drew closer, it was revealed the light was coming from a glass terrarium where the venomous viper snake was. The snake was large and thick, with its unique color scheme of dark and light bands. The basement had access points to both Biegenwald's apartment and Fitzgerald's. It had been being used as a makeshift laboratory for assembling pipe bombs and handguns with silencers. Also down here was the date rape drug known as Rohypnol, as well as chloral hydrate, which is a sedative and hypnotic drug. To aid them in their experiments was the *Anarchist Cookbook* sitting nearby. Several cigarette lighters they were altering into .22-caliber handguns were in different phases of completion. Glass beakers with latex membranes, which they used to extract the venom from the viper snake, lined the wall. Rounds upon rounds of ammunition were present, as if they were getting ready for combat. It was evident they were putting together a deadly combination of weaponry to be used to inflict mass causalities.

Hours were spent going over every nook and cranny; the .22-caliber gun that killed Anna Olesiewicz was found next to Fitzgerald's bed. However, the ammunition to that gun was in the basement bedroom where Biegenwald had been sleeping. In the upstairs bedroom, investigators found in Diane Biegenwald's jewelry box the black and gold ring they believed had been Anna's. Kevin Quinn meticulously photographed and documented each room and where everything was found. By now, the sun had come up, so Lucia, Miller and Mike Dowling returned to Ocean Township police headquarters to begin interrogating their prisoners. Everyone had now been awake twenty-four, and in some cases thirty, hours. Ken Kennedy was walking in Biegenwald's living room and saw Prosecutor Lehrer on the couch asleep; he had sat for a moment and dozed off. Kennedy saw a cockroach crawling on Lehrer's shoulder and brushed it off, waking him. "He looked up at me and said, 'Biegenwald is a good reason for the death

penalty.'" Kennedy was shocked he had said that for, just a few weeks ago, he had been standing next to Lehrer in a 7-Eleven watching him play Pac Man while they discussed why Lehrer was against capital punishment. As this case progressed and the number of dead bodies increased, Lehrer became ever more convinced the death penalty was appropriate.

At about seven thirty in the morning, Fagen and Lehrer returned to police headquarters. There wasn't much Fagen could do since the two suspects were being interviewed, so he wandered outside across the street to an all-night tavern. He wasn't a heavy drinker, nor did he drink in the morning, but on this occasion, it seemed appropriate. Fagen had been on raids before and knew they could be dangerous, but none had been quite like the one he just witnessed—explosive devices, an arsenal of weapons, poison and a viper snake made a drink necessary to calm his nerves. The drink went down fast, and he ordered another; on an empty stomach, the effects quickly went to work. Unbeknownst to Fagen, keeping with his reputation, Hollywood Al needed him because they were beginning a press conference. Fagen laughs, "Hollywood Al was up to his antics again." Al Lehrer was good at what he did, and he wanted others to know it.

The poor victim in that abandoned lot and the findings this case brought to light profoundly affected everyone involved. Detective Kevin Quinn penned a haunting song entitled "Anna Marie," which pays tribute to the teenager:

> *A young girl goes to the Jersey Shore*
> *to be with friends for a time.*
> *How could she know he would be waiting there,*
> *on the boards with his line.*
> *A young man kneels in the grass by you,*
> *his shield glistens in the light.*
> *A silent tear he has cried for you,*
> *for the beast had his thrill that night.*
> *Oh, Anna Marie, where have you gone tonight?*
> *Did you lose your way down by the sea?*

Chapter 13
Dead-Ends

Moments after the press conference ended, Billy Lucia went back to work. "Mike Dowling and I tried to talk to Richard Biegenwald. All he kept saying is: 'I want my shoes. Give me my fucking shoes.' The vein popped out on his forehead. I'll never forget it." However, no matter how hard the two tried, "[Biegenwald] wasn't going to talk, and we never did get anything out of him." Dherran Fitzgerald was less agitated and more controlled than Biegenwald but, nonetheless, uncooperative. After the two men were processed, printed and photographed, they were hauled off to the county jail. Formal charges would be filed after all the evidence was processed and the authorities knew exactly what they were dealing with.

"We met with Al," says Lucia. "He assigned Jimmy as DA and me as lead investigator." They were tasked, according to Lucia, with "cleaning up and trying to identify what [they] had."

It wouldn't be an easy task. The investigation turned out to be the most complex and important of both Fagen's and Lucia's careers. The case was solid with a key witness, Anna's ring and the murder weapon; however, it wasn't clear on who the actual triggerman was. The gun was in Fitzgerald's room and the ammunition in Biegenwald's. What was concerning to them was how many more victims there were. "You don't have to be Dick Tracy to figure out that this was probably an ongoing thing," says Lucia. Theresa Smith's account intimated more, but there were absolutely no leads whatsoever to indicate additional victims. Biegenwald never specifically told Theresa about killing anyone, but she knew all too well what he was doing on his excursions

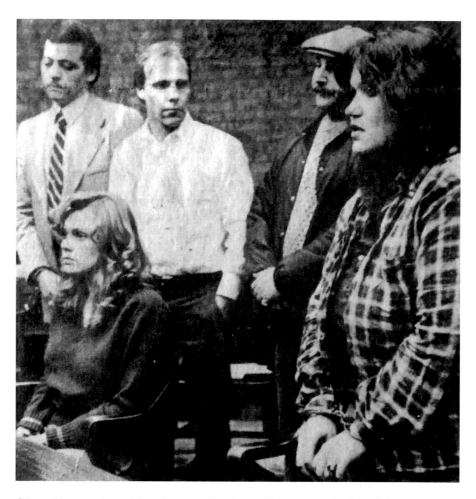

Diane Biegenwald and Jennifer Metz. Lucia and Fagen are to the left. *Asbury Park newspaper photograph.*

to relieve his anxiety. Lucia says, "Biegenwald wanted to groom her…[he] had hoped she would 'assist in killing these girls.'" Bringing Anna Olesiewicz home for Theresa was illustrative of this, as was showing her the body the next day. Lucia believes Biegenwald had planned to "use her to get these girls to accomplish whatever he wanted to do. He had plans, quite frankly, to continue this. There's no doubt in my mind." And although there's no proof of sexual assault, Theresa's mention of Anna's unzipped jeans suggests just that. If we are to believe that Smith and Biegenwald had a sexual relationship, it is quite possible his victims in some way aroused him, as the ones they soon would uncover had eerily similar features to Theresa Smith.

On Monday, the twenty-fourth, a meeting between Billy Lucia and James Fagen took place at the Monmouth County Prosecutor's Office at 132 Jerseyville Avenue in Freehold. It was a mild day, with temperatures above forty degrees and strong gusts of wind. As Fagen walked to the large brown-brick structure, his small frame met some resistance from the wind. Thousands of cases go through this building every year, and the floors are filled with assistant DAs and investigators. When Fagen sat down to talk with Lucia, his thick blond hair was out of place from the heavy wind. Over cups of coffee, the two discussed what they had thus far on Richard Biegenwald.

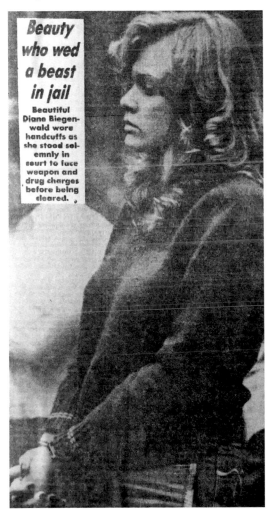

Beauty who wed a beast in jail

Beautiful Diane Biegenwald wore handcuffs as she stood solemnly in court to face weapon and drug charges before being cleared.

Fagen was confident the murder case of Anna Olesiewicz was solid and that forensics would match the gun found with the bullets extracted from Anna's skull. The ring in Diana Biegenwald's jewelry case was certain to be Anna's, and arrangements were made to have Anna's parents and boyfriend confirm it was hers. Additional time was needed with Theresa Smith to iron out the details and obtain her formal signed statement. She was also needed to positively identify the ring as the one Biegenwald had taken off the lifeless body in the garage. By the meeting's end, a detailed punch list of what was needed was complete. Once this was done, they talked further about what was next. To paraphrase Donald Rumsfeld, the wordy yet distinctive secretary of state under President George H.W. Bush, there were things they knew they didn't know and knew they didn't know them.

Beauty and the beast. *Asbury Park newspaper photograph.*

In simpler words: there were more victims. Lucia was tasked with finding them and developing a case against Biegenwald. And although they weren't sure of Fitzgerald's role in the Anna Olesiewicz case, they were certain it was minimal. "We were pulling names of missing girls and a timeline," says Lucia. They worked backward in time, researching where Biegenwald had lived and what women went missing during those periods. The list contained many names, three of which were Maria Ciallella, Deborah Osbourne and Betsy Bacon. All three would prove to have died at the hands of Richard Biegenwald.

For the next three months, Fagen and Lucia would meet periodically to go over the upcoming Olesiewicz trial and the ongoing Biegenwald investigation. As time moved on, it became apparent that they had no credible leads on any additional victims. The apartment search had failed to provide any evidence to suggest there were other victims.

ON A SPRING MORNING in April, James Fagen was sitting at his desk going over his upcoming schedule when the phone rang. It was an old friend, Jonathan Steiger, on the line. He and Fagen had known each other for years, and Steiger was godfather to one of Jimmy's kids. The conversation was pleasant, with the informal "how are things?" etc. However, Jon Steiger wasn't calling his friend to chitchat. He was calling on behalf of his client, who had information to share with the prosecutor's office. His client's name was Dherran Fitzgerald.

Chapter 14

Guns, Drugs and Killings

Jonathan Steiger told Fagen his client was willing to provide the state with additional victims in exchange for a plea deal to avoid the charge of murder. Steiger said his client had nothing to do with any of the killings; however, he had helped Biegenwald dispose of several bodies. Fagen was stunned. He called Lucia about the offer, and they set up a meeting. The meeting took place at the Monmouth County Prosecutor's Office around the second week of April, just as the cold dreariness of winter was transitioning to warmer spring weather. Spring fever was in effect, and spirits were high, so it was appropriate that Fitzgerald came forward when he did.

Arriving at Fagen's office early in the morning, Jonathan Steiger and Jimmy sat chitchatting as they waited for Fitzgerald to arrive. When police brought Fitzgerald in, he was unshaven, his hair was gray and he was dressed in prison garb with his feet and hands shackled. Fitzgerald had done time before but never for murder. When he sat down, a slight odor of perspiration emanated from him.

As Fagen and Lucia listened, Fitzgerald sat calmly and, in a strong voice, said he had helped dispose of Anna Olesiewicz's body. He didn't know the girl's name at the time, but it was Biegenwald who killed her, stored her body under a mattress in the garage and asked for Fitzgerald's help to dump the body the following night. However, this was not the first body he had helped his friend get rid of.

To help understand the two men's relationship, Fitzgerald explained how they met. In 1966, he had robbed a housing project and, as a result, was

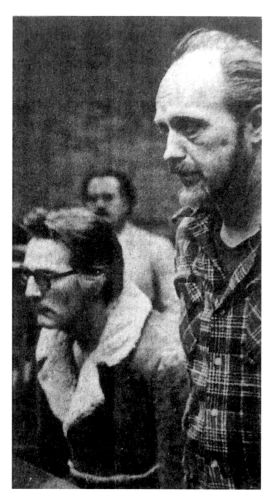

Fitzgerald and Biegenwald being arraigned. The mark on Biegenwald's cheek is a result of the 1958 shooting. *Asbury Park newspaper photograph.*

sentenced to a term of thirty to thirty-five years in prison and shipped off to Rahway State. It is here where he occupied the same wing of the prison as Richard Biegenwald. Eventually, the two became close and used to talk about their criminal pasts. Fitzgerald was eventually transferred to Leesburg State Prison in Maurice River, New Jersey, where met another man with whom he became fast friends: William Ward. Ward was a decade Fitzgerald's junior and was serving time on drug possession and burglary charges. Sometime in late 1976 or early 1977, Fitzgerald was released on parole, but in June 1977, in Haslet, New Jersey, he was arrested for being in a stolen car while wearing a ski mask and being in possession of a handgun and was sent back to prison. While back behind bars, he was caught trying to smuggle bomb parts into prison, and nine months were added to his sentence.

His friend William Ward escaped Leesburg in November 1978.

When Fitzgerald was again paroled, he found Ward working in a gunrunning operation and asked to join in. Shortly after, he recruited Biegenwald—who was living at 801 Ocean Avenue in Point Pleasant Beach—to become their "enforcer." He would be their insurance policy to keep things from going wrong. On one gunrunning trip, Fitzgerald and Biegenwald bought weapons at a Florida gun shop and provided Trenton State Prison's address as their own. In the spring of 1982, Biegenwald asked

Fitzgerald to see "something he had in the garage." In the back, under a mattress, was the body of a young woman whose head was wrapped in a plastic garbage bag. Fitzgerald asked what had happened and was simply told, "It was business." He knew not to ask any additional questions. Later that night, in the garage, the two chopped up the body and put the pieces in green garbage bags. They then put the remains in the trunk of their car and drove over to Biegenwald's mother's place at 420 Sharrotts Road in Staten Island. There, in the middle of the night under a bright moon, Fitzgerald started digging a hole to bury the body. As he dug, his shovel came across a previously buried body. Fitzgerald looked up and was told: "Another business deal gone bad."

This was a case beyond Fagen's and Lucia's imaginations. Just when they thought Fitzgerald was done, he spoke of William Ward and his demise. On either the morning of September 21 or 22—he wasn't sure of the date—Ward and Fitzgerald were arguing over money when it turned physical. A gun was pulled, and the two wrestled for its control, crashing through a screen door and onto the front lawn. Biegenwald heard the commotion and ran outside, where he saw the two men grappling. He then calmly pulled out his .22-caliber handgun with silencer and shot Ward in the head. Four additional rounds were shot into his head before Biegenwald and Fitzgerald pulled him into the garage at the back of the property. That night, they buried Ward in a cemetery in Neptune, New Jersey. And finally, there was another body Fitzgerald could lead them to in a remote area of Tinton Falls, New Jersey. This one was a young woman Biegenwald had killed sometime before Thanksgiving of the previous year. Fitzgerald couldn't speak of the details, as his only role was helping to bury the body.

Fitzgerald spoke of his increasing frustration with Biegenwald, especially after he had killed his beloved cat, and he said he was going to terminate his relationship with him, but then the news broke in January of the body being found in the lot. When Fitzgerald was done, silence filled the room. Then Steiger and Fagen worked on getting as many specific details from Fitzgerald—including dates, names and places—as they could. No promises were offered prior to determining his role in the killings.

Upon researching the dates provided, it was speculated that Maria Ciallella was one of the victims, and her body was likely to have been the one Fitzgerald came across while digging the first grave. Fitzgerald had been in prison during her disappearance in November 1981. Additionally, other dates matched with people who had gone missing. "We cut a deal

with him," says Fagen. Fagen thought Fitzgerald "a likeable person…[and] a bag of wind." According to him, Fitzgerald was all show and not the person he wanted you to believe he was. Prosecutor Lehrer offered a deal of ten years in prison for his assistance in locating the bodies and testifying at trial.

Chapter 15

"Perverted, Sick Individuals"

The bodies in Staten Island complicated matters, as New York authorities would have to authorize a warrant for the property there. Fagen and Lucia's plan was to first go after the bodies in New Jersey and then go across the river with an affidavit in hand.

The first victim they would search for required no search warrant, as she was laid in a makeshift grave in a wooded area in Tinton Falls. They believed this victim was Betsy Bacon, a seventeen-year-old with long, fluffy dark hair and brown eyes. She was teenager who was meticulous about her looks, with thinly trimmed eyebrows and a wide smile that highlighted her perfectly white teeth. Betsy had gone missing the weekend before Thanksgiving in 1982. She came from the affluent town of Sea Girt, with its beautiful homes painted in bright pastel colors. Sea Girt sits right on the Atlantic Ocean and is a quaint community only one square mile in size. It was the evening of Saturday, November 20, when the teenager left her home at about 11:00 p.m., telling her parents she was going out to buy a pack of cigarettes. That evening, her family went to bed and woke the next morning to find that their daughter had never returned home.

On Thursday, April 14, "Bill and I," says Fagen, "went to police headquarters in Sea Girt for reports on Betsy Bacon." The weather was beautiful, with the temperature in the mid-fifties. The ocean air was crisp and wafted under their noses as they walked into the police station. They introduced themselves, and the officers there were cordial but not overly concerned for the young woman. Fagen remembers one of them saying,

"She's no good; she's probably hooked up with some junkie in New York." Once the two received the file they were looking for, they walked back to Lucia's car, and Fagen told Lucia, "Boy, is he going to be sorry for saying that tomorrow."

The following day, a contingent of officials converged on the isolated area in Tinton Falls. The day was clear and the weather mild as investigators began a grid search of the wooded area, which was filled with dirt mounds. Presumably, some excavating had been done in the area, and this was the reason for the mounds of dirt. Fitzgerald recalled laying the body next to one of these mounds and pulling the dirt over the corpse. Lucia remembered Fitzgerald had told him "debris and stuff were over the grave to hide it." Hours had passed as investigators searched the area. Then, as the sun began to fade, Lucia called it a day and began preparations to secure the area overnight until they could resume work in the morning. As he walked, he gazed at a dirt mound and then stopped and took a second look. A hand was sticking out from the dirt. If their long search had inspired any doubt in Fitzgerald, it was immediately quelled.

How or where Betsy Bacon encountered Richard Biegenwald is a mystery, but it in all probability, it was when she was walking on Route 17 near the 7-Eleven store. As with most of his "thrill killings," the real story can never be known because Biegenwald operated alone in the dark recesses of the night and never spoke of his killings. The closest he came was intimating to Theresa Smith about what gave him a thrill.

Billy Lucia knows this better than most: "He wasn't going to talk, and we never did get anything out of him." What investigators did find was that Biegenwald shot the seventeen-year-old victim in the head with his .22-caliber handgun. He wrapped her head in a garbage bag to contain the blood and stuffed her in his car. He brought her to the Asbury Park apartment, where she was prepped for disposal the next night. Although Betsy Bacon was the first body uncovered, hers was the last to be identified.

On Sunday, Lucia arranged a search of the Mount Cavalry Cemetery in Neptune, New Jersey, right off Route 66. There, Fitzgerald said, lay the body of William Ward. It was never determined why Fitzgerald and Ward were fighting, but it was believed to be over an attaché case full of money. Two women in the upstairs apartments heard the noise and saw Biegenwald standing there. He concealed the weapon and told them not to call an ambulance, as he was going to drive Ward to the hospital. After Biegenwald's arrest, one woman spoke of her decision to remain silent: "I'll have to live with this the rest of my life…nobody knows what I've

been through. What was I to do at the time? I was frightened then, and I'm frightened now."

As investigators combed the cemetery, it began to rain, causing the digging to be a muddy mess. Fortunately, Fitzgerald was able to identify the exact spot where he buried the body. Mike Dowling says it was a well-thought-out burial, and he credits Fitzgerald with the selection. "[Biegenwald and Fitzgerald] went to the cemetery and noticed that the excess dirt was regularly bulldozed to the side of this hill which dropped down about thirty or forty feet." It is in this location that Ward was buried. "They figured, in another six months, [Ward] would be buried sixty feet below ground…If Fitzgerald didn't give up the body, it would still be there."

The autopsy showed that Biegenwald shot William Ward five times in the head—a cold-blooded execution and one he didn't think twice about. Biegenwald was a sociopath who had manifested extreme antisocial behavior and a lack of emotion his entire life. Prosecutor Al Lehrer coined Biegenwald the "Jersey Shore Thrill Killer," an odd name for a sociopath. Nonetheless, it was a befitting title, as he got his kicks out of killing women. In Ward's case, it was more a matter of circumstance than thrill.

Chapter 16

"It's a Chop Job"

With two bodies recovered and Fitzgerald saying two more were in Biegenwald's mother's yard, Lehrer and Fagen were now ready to head over to New York. "I put together an affidavit," said Billy Lucia. "Jim and I went over to Staten Island." With the affidavit in hand late in the morning of Tuesday, April 19, they headed out to present their case. As they drove, it began snowing lightly, but it had turned completely to rain by the time they parked on Stuyvesant Place. The New York District Attorney's Office was not much bigger than New Jersey's, and it didn't have the architectural splendor commonly seen in such legal buildings in cities. It was simply a large steel structure with glass windows. Normally, the sun's light would cast brightly on the metal, giving it more of a welcoming feel. Today, the sky was gray and the look was dreary.

William Murphy had recently been appointed district attorney by Governor Mario Cuomo after the previous DA was elected to the state Supreme Court. Murphy was eager to prove himself, as he would have to run for election to keep his position. He was born and raised in the New Brighton section of Staten Island and attended the local schools there. As a youngster, he rose to become an Eagle Scout and did well academically. He attended college at Fordham and received his law degree from Harvard. It was on New Year's Day 1976 that he was sworn in as an assistant DA on the island. Over the years, he had worked several notable cases that brought him into the limelight. Murphy was proud of his accomplishments, and the year before, he had successfully prosecuted a landfill supervisor named John Cassiliano for taking bribes in order to allow illegal dumping of toxic waste. This was at a time when few, if any, environmental laws

William Murphy (center) and Al Lehrer (right) at a press conference. Asbury Park Press *photograph.*

existed, and it was a hard-fought victory for Murphy. His actions were partially responsible for the environmental laws that now exist in Staten Island. Murphy looked the role of a city DA; he was tall, wore nice suits and had a distinguished look with his graying hair and mustache. The black eyeglasses he sported gave him an educated look.

On this day, the DA greeted his visitors with a professional deportment and invited them into his spacious office with large windows lining the walls. Spectacular views of Upper New York Bay and the Kill van Kull were the center point of his office. After some informalities and pleasantries, James Fagen began explaining why they were there. "[He] kinda thought we were stupid," said Fagen. "It opened up my eyes." Fagen never imagined he would come up against resistance to what he had presented. Billy Lucia laughs, saying, "They probably thought we were nuts."

Despite the arrogance and belittling, a New York judge granted a search of the property at 420 Sharrotts Road. The operation was to be under the control

Bobby Miller (center) at the burial site. Staten Island Advance *photograph*.

of the Staten Island DA and New York law enforcement officials. A call was made to Bobby Miller to pick up Fitzgerald from the jail and bring him over.

Miller picked up Fitzgerald in a marked police car, and the two began the trek. They had talked in the past, and the conversation was comfortable and friendly. "He was a very interesting guy," says Miller. "He liked jumping out of airplanes and did a lot of things that take some balls to do." Miller says the difference between Fitzgerald and Biegenwald was that if "you looked into [Fitzgerald's] eyes, it was fine. You look into Biegenwald's eyes, there was nothing there." During the fifty-minute ride, the prisoner opened up a bit. "He told me he kills people for $2,000." Then he switched his talk over to Biegenwald, mumbling something. Miller asked, "Whatchya talking about, Dherran?"

"Richie Biegenwald is lazy…when he kills somebody, he doesn't bury his bodies; he's lazy as hell."

As the two got closer to their destination, the conversation dwindled to silence as Miller turned onto Sharrotts Road.

Sharrotts Road is a long stretch of pavement that cuts through a state park reserve. Much of the road is wooded, with dense trees and brush lining the way. As you move closer to number 420, the homes get closer together, and it has more of a traditional neighborhood look. Miller pulled his car into the eight-

foot-wide driveway of Biegenwald's mother's house, while Prosecutor Alexander Lehrer, who had been following behind, parked on the street. Paul Jones, an investigator for the Monmouth County Medical Examiner's Office, and his colleague arrived on the scene as well.

The house was quaint, blue in color and not well maintained. The side yard was vacant, with overgrown grass, and the property was next to the state reserve, which had bamboo stretching high into the air. The house was a one-story structure with concrete steps leading to the front door. Sitting back about forty feet from the road was a detached wooden garage that was in decay. In the backyard, there was another set of steps leading into the home. Investigators knocked on the door, and the elderly Sally Biegenwald wasn't overly surprised to see police. Sally, whose hair was completely gray, was a pudgy woman standing maybe a little over five feet tall. She was soft-spoken and polite, and from looking into her house, one could tell she was neat and clean. The home was decorated nicely, and the furniture was kept in good condition. Her walls were lined with white drapes, which made the inside a bit dark. Sally was presented with the warrant, which allowed authorities to search the yard only. New York authorities did not authorize a warrant to search the inside of her residence.

Because Murphy didn't lend much credence to Fagen's insistence that bodies were buried on the property, he sent only one representative from his office and a uniformed cop to oversee the search. It would be Lucia and Miller who would be shoveling dirt to uncover the bodies. The arrogance of the Staten Island DA's office was over the top, and even the uniformed cop stood off in the distance, paying little attention to the operation.

Lucia and Miller took the shovels out of the back of Miller's car and asked Fitzgerald to show them where to dig. Fitzgerald, seeming to take his time while walking, simply pointed down and didn't utter a word. The spot was to the right of the detached garage where aged firewood sat on two large pieces of plywood. "When [they] removed the plywood," Miller said, "you could smell the putrid odor of rotting flesh." The water table in this area was high, and the rain made things worse for digging. "We hit the plastic bag that Fitzgerald had described," says Miller. Immediately after they pulled up one of the bags, the Monmouth County Medical Examiner's two people took over. "It was terrible," remembers Lucia. The smell was overwhelming, causing several people to step back. However, now the Staten Island assistant DA and the cop moved closer with looks of "oh, shit" on their faces. "The guy from our ME's office," said Miller, "got down in the hole and then was pulling up the bags and said, 'It's a chop job.' I said, 'What are you talking about?' He said, 'They're all cut up.'" The two New York officials "went crazy." The assistant DA ran to the phone,

Lou Diamond (far right) looks on. Staten Island Advance *photograph.*

and literally within minutes, marked police cars were on the scene. "Then," says Miller, "it became important." The arrogance of Murphy and his office came back to bite them in the ass. The big-city/small-cop attitude, however, didn't end there. Once the bodies were found, it became a "turf war," says Fagen. Jersey authorities were told to stop digging. "They just took over...[and] would not release the bodies." From that moment on, "it became a pissing match between New York and New Jersey," says Fagen.

As New York took over, Fagen, Lucia and their crew stood and watched as green garbage bags with cut-up pieces of the victims were extracted from the muddy three-foot grave. Night began to fall, so the digging operation was halted and would resume in the morning. The Jersey contingent left and returned over the river, with Bobby Miller dropping off Dherran Fitzgerald at the county jail. The images and smell of the bodies were etched in his mind as he pulled into his driveway. "That's what the general public doesn't understand. You close your eyes and you see dead bodies." He walked into his modest home and crept up the steps so as not to startle his wife. The quietness of his home was calming and provided shelter from what he knew was beyond his four walls. Miller says, "I took a nice hot shower...I got the stink off me, then went to bed."

The next morning was bright and sunny, with a crisp forty-degree temperature. The morning newspapers were filled with headlines about Richard Biegenwald

and the unearthed bodies. One paper read, "N.Y. yard may yield more bodies," while another stated, "Bodies unearthed at murderer's home." William Murphy, the initially condescending DA, was quoted as saying, "We have reason to believe there are more bodies out there, based on information provided to us." The *Staten Island Advance* reported that upward of twenty-five bodies could be found in and around the property. The local radio stations and even the major New York City stations were talking about Richard Biegenwald. Who was he? And how many people had gone missing at his hands?

As the search resumed, a large, yellow machine backhoe was brought in to make digging faster. Lou Diamond had been called by Sally late in the night and was now representing her son. Later in the day, cops came across several bones they believed to be human remains. "I got a call from…Channel 2 News," Lou Diamond says. "They were just starting 'Live at 5' then, and the reporter said, 'I got the truck and I have three minutes of air time.'" Diamond drove quickly to Sharrotts Road. "I get there, and he's like crying," Diamond says of the reporter. The ME personnel had concluded that the bones belonged to a dog. They were literally minutes away from a live broadcast, and the reporter was beside himself. Diamond said, "Don't worry about it; roll the cameras." Streaming live on TV, the interview began: "Mr. Diamond, I understand there's been another find," said the reporter, moving his microphone closer to Diamond. "Yes," replied the attorney. "These machines," pointing for the camera to the backhoe, "have seemed to recover some bones and things." Continuing, Diamond said, "The medical examiner over there," pointing once again, "is trying to identify them." The reporter, moving the microphone to speak, said, "Do you have any speculation on what it may be?" With his quick wit, Diamond said, "Actually, no. Except I don't think Lassie is coming home."

This would be the first in a series of shocking demonstrations put on by the flamboyant Louis Diamond. He liked publicity and was better at playing the media game than even Hollywood Al Lehrer. For Lou Diamond, his career was based on an attitude of confidence highlighted by a degree of flamboyance. "I'm competing against people that were twenty-five years older than me. So I needed to do something to get attention." Diamond, however, was much more than a man of sartorial splendor. "That will only get you so far," he says, referring to his look. He was a man of substance. A man of talent. And a man of perseverance. "You have to be good. You better win." And win he did. He represented people across twelve different states and kept coming up with an acquittal each time.

Chapter 17

"It Was a Terrible Thing"

While the search continued on Staten Island, Jimmy Fagen and Billy Lucia were over in Manhattan at the Chief Medical Examiner's Office to witness the autopsy.

The Medical Examiner's Office was much larger than that of Monmouth County's. The chief medical examiner was Dr. Elliot Gross, a man in his late forties who was educated at New York University. His city roots ran deep, as his father, Dr. Samuel Gross, was a police surgeon who investigated crime scenes. Elliot was born, raised and educated in New York City, and after his education, he spent seven years as chief of the Armed Forces Aerospace Institute in Washington, D.C. In 1966, he decided to move back to New York City and began working for the medical examiner there. Four years later, he moved to Connecticut and became chief medical examiner. He worked in that capacity until the late 1970s and then moved back to New York City, where, before the decade was over, he would be appointed chief medical examiner.

James Fagen and Billy Lucia met with Dr. Gross before the autopsy and were asked to put on white laboratory jackets. Then they were brought into the main examination room. The room was cold—a necessity when dealing with dead bodies—and the two noticed the largeness of the place. Both had been to autopsies before, but this room was much larger than any in New Jersey. The nomenclature, however, was the same; the floor was lined with square white tiles. At several different locations on the floor were drainage grates. The walls were also tiled in white, which allowed for easy cleanup

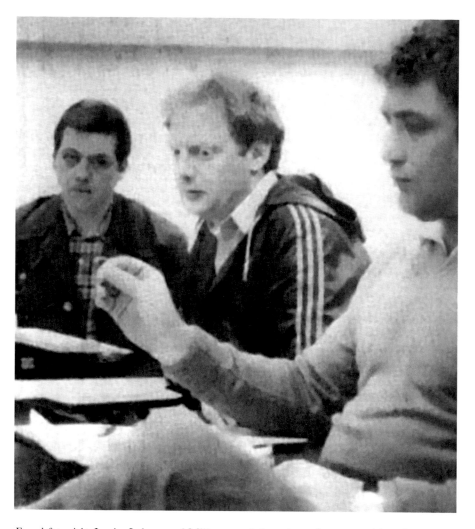

From left to right: Lucia, Lehrer and Miller examining a bone fragment. *Asbury Park newspaper photograph.*

when things got a little messy. Stainless stair doors, which were refrigerated storage compartments for bodies, lined one wall. Each door had a shiny chrome handle that looked as if it had been just polished; not even a fingerprint could be seen. In the center of the room stood the main table where the examination was going to take place. The table was constructed of stainless steel and had a large drainage bin at one end. Spread throughout the room were stainless steel gurneys used for transporting bodies. Scales of different sizes, used to weigh body parts and organs, were located at several

locations. Water hoses could be seen at the various examination areas, and one was propped up by the main table toward which they were walking.

Dr. Gross wanted to examine first the body that had been in the ground the longest. "It was horrible," said Lucia. "The bodies were in the ground for over a year in wet soil." The smell consumed the room and turned the stomachs of both men. Dr. Gross seemed unaffected and continued with his examination. "It was one of the worst things I have ever smelled," recalls Lucia. "I have smelled a lot of dead bodies. I had one in Wall Township in July." The victim wasn't found for "three to four weeks, and part of her head on the pillow was nothing but maggots. This," says Lucia, "was much worse."

It is necessary for police to be at an autopsy should evidence be found that needs to be taken into custody. This is known as maintaining the "chain of evidence." New York officials were on hand to handle this, as the "pissing match" continued. Eventually, all evidence in the matter would be turned over to New Jersey officials. For now, Fagen and Lucia were there to observe and take notes should there be any discrepancy with what New York officials documented.

As Dr. Gross was examining body parts of the victim, Lucia couldn't get the image of Maria Ciallella out of his mind. He had seen her picture. "She was a pretty young girl. I just kept seeing that picture in my mind...It was just heartbreaking."

Maria Ciallella, like all of Biegenwald's "thrill killing" victims we know of, had long black hair and big brown eyes. Her smile was attractive and inviting—and young. She was only seventeen. She was abducted by the "Jersey Shore Thrill Killer" as she was walking on Route 88 on Halloween night in 1981. Maria had told her father she would be back about midnight, and a Brick Township police officer saw Maria walking as he drove by en route to a call. The officer reported that he was going to stop and pick the girl up after the call. Ten minutes later, he went to do just that, but she was gone. It can only be assumed that Biegenwald used his charm and nonthreatening blue eyes to lure his victim into his car. According to Alexander Lehrer, Biegenwald "shot [Maria] in order to watch her die." Biegenwald was living nearby on Forman Avenue, in Point Pleasant Beach, New Jersey, and he buried his young victim under the basement floor. At a later time, he dismembered the body and brought it to his mother's yard.

Upon examining the skull, Dr. Gross discovered two circular holes, which he determined to be bullet holes; inside the skull were two bullets. Based on the state of decomposition, Gross concluded that the body had been buried for a year or more.

The next body Gross examined was believed to be that of Deborah Osborne. A picture of Deborah shows a young woman with long, dark hair and brown eyes—a common denominator amongst the victims. And presumably, all were recreational marijuana users. This was the bait used to reel them in. Deborah had gone missing on Monday, April 5, 1982, after hitchhiking with a friend to a popular watering hole called the Idle Hour Bar on Route 88. Ironically, this was the same road Maria was last seen on. The legal drinking age in New Jersey was eighteen at the time, and both girls planned on doing just that. The Idle Hour

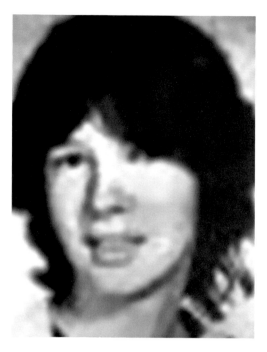

Deborah Osborne. New York Times *photograph.*

Bar was in Point Pleasant, just a stone's throw from where Biegenwald was living. Sometime during the evening, Deborah's girlfriend went to the ladies' room, and when she returned, Deborah was gone. Authorities believed Deborah left the establishment without her friend and was picked up by Biegenwald. It is just as likely that Richard Biegenwald was sitting in that bar watching, and when her friend went away, he moved in. Maria Ciallella, Betsy Bacon and Anna Olesiewicz were all shot with a .22-caliber handgun; however, Deborah Osborne was stabbed twenty-one times. Regardless of whether she was hitchhiking or had left the bar with Biegenwald, she apparently had second thoughts about the man and presumably refused to get into his car. Deviating from his preferred method of killing, the number of knife wounds suggests a level of anger and frustration not commonly associated with Richard Biegenwald.

As Dr. Gross examined the remains, the decomposition was to a lesser degree than with the first body, and Gross confirmed that the cause of death was multiple stab wounds to the abdomen and chest. Dental records would be used to positively identify the victim.

Five days later, on Monday, April 25, Lou Diamond went to Trenton State Prison to speak with his client. By now, the media was enthralled with

the case, and Sue Simmons of the *New York Daily News* followed Diamond down to cover the event. According to Diamond, Biegenwald was in a cell similar to the one "Hannibal Lecter" was held in in the movie *The Silence of the Lambs*. Lou's daughter was only an infant at the time, and as his means of communicating with Biegenwald, Diamond used her Mickey Mouse whiteboard eraser set. While sitting in a room alone with his client, Diamond began writing on the whiteboard rather than speaking. "I think this went a long way," Diamond says, "in establishing his trust." Once the words were erased, they were gone for good. Diamond laughs, saying, "I think it is the first time in the judicial system that Mickey was involved in a multiple murder." Sometime during this interview, an inmate on the opposite side of the prison attempted an escape. His name was Robert J. Stankiewicz, twenty-one years old, and he was shot and killed by a prison sharpshooter while his accomplice tumbled onto the barbed wire. Both inmates were serving time for murder. As a result of this attempted escape, prison officials put the prison on "lockdown," and guards in riot gear were assembled. As Diamond walked out into the exterior lobby where Sue Simmons and the news crew were waiting, guards in riot gear burst into the room. Diamond, with his quick banter, said, "OK, gentlemen, I'm ready to go."

Chapter 18

"All This Guy Had on His Mind Was Killing, Killing, Killing"

On Monday morning, May 9, Diane Biegenwald and Fitzgerald's girlfriend, Jennifer Metz, were arraigned before Judge Thomas Shebell Jr. As Diane walked into the courtroom, she looked radiant in her tight blue jeans and knit sweater, which highlighted her busty figure. Her hair was long and curled, and one newspaper reported her relationship with Biegenwald as resembling "Beauty and the Beast." Jennifer Metz was also an attractive women, but her appearance was unkempt, and she wore oversized jeans and a long-sleeved flannel shirt that wasn't tucked in—presumably to hide her excess weight. Billy Lucia and James Fagen stood directly behind Diane as Shebell read the charges out loud. Neither had anything to say, and both were remanded to the Monmouth County Jail. The next day, Dherran Fitzgerald stood silent as Shebell read his charges. It would take a week and a half before Richard Biegenwald would be arraigned.

Ever since Al Lehrer's press conference, the newspapers had been filled with accounts of the investigation fueled by "Hollywood Al's" statements. It is Lehrer who coined the saying the "Jersey Shore Thrill Killer." Newspapers across the country reported on Richard Biegenwald; "2 Suspects Arrested in 'Pleasure' Killing," read the *Asbury Park Press*. Other headlines read, "4 Bodies Dug Up in Slaying Probe" and "Prosecutor to Seek Death in Murder for 'Pleasure.'" Prosecutor Lehrer's strong statements about Biegenwald and Fitzgerald also filled the papers. "These people are a bunch of sickos…they're in jail where they belong," read one paper. But it was Lehrer's description of Biegenwald killing for the thrill of it that took hold. On Wednesday, May

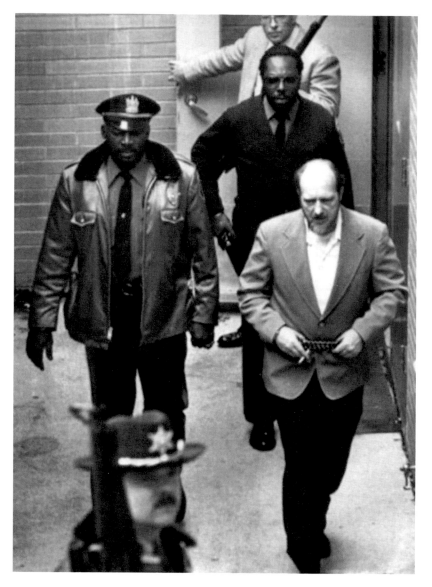

Escorting Biegenwald into the courtroom. *Associated Press photograph.*

20, 1983, scores of media personnel were gathered outside the courthouse to get a look at the "thrill killer" as he was brought in for his arraignment.

When Richard Biegenwald stepped out of the prison van, the cold-blooded killer the media had envisioned looked more like an unassuming middle-aged man wearing casual business attire. Biegenwald was smoking a

cigarette as he was escorted into the courthouse in chains. Silence filled the courtroom as the prisoner was brought in. Those lucky enough to get a seat were able to get a closer view of the murderer and a whiff of the cigarette smoke from his clothing. He was seated next to his attorney, Lou Diamond.

It had been reported by several sources that Richard Biegenwald showed a lack of emotion. This wasn't the case as he sat in court. The signs of stress are clearly visible on his face in photographs of his arraignment. He sat silent and didn't utter a word during the arraignment. Afterward, he was remanded to Trenton State Prison. A trial date was set for July.

Throughout the spring and into the summer, newspapers were filled with accounts of Richard Biegenwald and the bodies police had uncovered. The prosecutor's offices, as well as police, were riddled with phone calls from concerned family members who had loved ones missing. Publicity was relentless and caused Lou Diamond to request a change of venue for the upcoming trial. However, the judge refused, instead saying he would allow time to pass in the hopes that the media attention would dwindle. He reset the trial for November.

The extra time allowed for James Fagen and Billy Lucia to follow leads they had on additional victims, one of whom was a man named John Patrone. Patrone was a low-level criminal who had dabbled in robbery and forgery dating back to the 1960s. Patrone was an ex-con who went by the nickname "the Cigar," and he hadn't been seen or heard from since June 1978. In June of that year, Biegenwald was on the run from the attempted rape charge, and it is believed he was running in the same circles as Patrone. The story centering on Patrone's disappearance was that he tried to extort money from Richard Biegenwald's mother by saying he was sent by her son to get money from her.

Shortly after this, in a ruse, Biegenwald took Patrone target shooting, and Patrone was never seen again. The story of Patrone's demise could only have come from Biegenwald, but it isn't clear to whom he told it. It was more than likely Fitzgerald. Nonetheless, the story goes that Biegenwald, as a sign of trust, emptied his weapon completely into his target, which was pinned on a tree. Acknowledging this sign of respect, John Patrone emptied his weapon into the same target. What Patrone didn't realize was that Biegenwald had done a bait and switch; he pulled out a second gun—probably his trusted .22 caliber—from under his shirt and shot Patrone dead. The story concludes with a visit to state prison to see Dherran Fitzgerald, where Biegenwald whispered through the thick Plexiglas window, "The Cigar is out." Along with this account came information that a man called "Piggy" Hurley knew

where John Patrone was buried. Hurley, who got the nickname "Piggy" because of his four-hundred-plus-pound frame, had recently come into a great deal of money. Investigators believed—but couldn't prove—that it came from a jewelry heist. Supposedly, "[Biegenwald] presented Hurley with plans of robbing a jewelry store," and Hurley betrayed this trust and went it alone. He then went into hiding for fear of retaliation and had only recently resurfaced after Biegenwald's arrest. "I got this impression," says Fagen, "if anyone thought that Richie Biegenwald wanted to kill you, they were afraid...I remember one guy just took off and when I asked him why he said Richard Biegenwald said he was going to kill me." All who knew the man knew this was not an expression of anger but a statement of fact.

With this information, Fagen thought to himself, "I'm going to call Hurley before a grand jury." However, it wasn't going to be that easy. Whether or not the man was behind bars, Hurley didn't want to speak out against Biegenwald, and he hired an attorney. According to Fagen, the attorney said "his client isn't going to testify...and will take the Fifth Amendment if forced to." Fagen argued back, "Yes, he is. I am going to give him immunity. He didn't kill anyone. I want his information." However, "the attorney got all bent out of shape and [went] to Al Lehrer," who in turn told Fagen, "They'll give us the information, but don't call him before a grand jury." As a seasoned attorney, Fagen knew the ramifications of doing such a thing. "The next thing I know," says Fagen, "I'm in a car following behind" Hurley and his attorney. It would be a short sojourn into an isolated state reserve area of Jackson Township in Ocean County. "We start digging," says Billy Lucia, "and sure enough, we find John Patrone." Well, almost all of him—"his head was gone." It was a remarkable story that concluded with the recovery of a body. However, "the problem is now," says Fagen, "we have a body, but without Hurley, I can't prove anything...this was a bad mistake on Lehrer's part." Lucia confirms this by saying, "We never were able to prove it was Biegenwald who killed Patrone."

Another possible victim—but never proven—was Virginia Clayton of Freehold, New Jersey. Clayton, seventeen years old, was last seen on Wednesday, September 8, 1982, and her body was discovered three days later in a ditch less than four miles from where John Patrone was found.

Dead-ends were a common occurrence when trying to pin things on Richard Biegenwald. It was certain that he killed Patrone and likely Clayton, but there was nothing authorities could do. If there was one thing learned, it was that Biegenwald covered his tracks. If not for Theresa Smith coming forward, authorities would have had no clue who killed Anna Olesiewicz.

That case was colder than the Jersey Shore in February. And Dherran Fitzgerald came forward as a witness only after he became a casualty of Smith's betrayal.

In preparation for the upcoming trial, Richard Biegenwald had numerous discussions with his defense attorney. Because of what his attorney had done for him in the past, Biegenwald had tremendous respect for and trust in Lou Diamond. "It's the question not asked," says Diamond, "that can build trust." It seems the man who got a thrill taking the life of someone else didn't want to lose his own. In an attempt to avoid the death penalty, he told his attorney he could produce more bodies if he were to receive a plea deal for life in prison. "I'll take you right to them," Biegenwald said. "I came to Jimmy [Fagen] at the beginning of the case and said, listen, I give you twenty-five bodies so these families can have closure; take the death penalty off the table, we'll take the pleas and go home." Fagen was shocked by this proposal and knew it wasn't his call. "Lou [came] to us on the eve of picking our first jury" with that information, Fagen says. "You had to go to your superiors."

The offer came right after Alexander Lehrer's tenure as prosecutor ended. Charles Buckley, a hardworking attorney who considered himself part of the blue-collar class, was now the acting prosecutor. He was not as gregarious as Hollywood Al or Lou Diamond but was just as talented. "I remember Buckley thinking about it," says Fagen. "And others saying, 'You can't do that. How's it going to look? You have this guy for the death penalty, and he's going to give you more bodies and you're not going to kill him?'" Ultimately, Buckley turned down the offer and prosecuted Biegenwald for the death penalty.

"It was one of the worst things I've ever seen," says Diamond. "I would like to have seen these [families] have closure."

Chapter 19

"He Already Tried the Case in the Newspaper"

Jury selection began the week of November 14, 1983, with the newspaper coverage the night before detailing the case. The first order for Lou Diamond was to renew his request for a change of venue. The judge denied the change of venue with a stipulation that if 250 jurors indicated they could not be impartial, he would make a venue change. The *voir dire* procedure was long and tedious for both the prosecution and defense.

"That was the worst part," says James Fagen.

Diamond, on the other hand, thought differently. "I love these people. I love to break them down. They say that picking a jury is an art. I think if you're a street guy, you can pick a jury…There are people that want to sit on big cases. Anybody who said they didn't know anything about the case is a liar." The case did get extensive national coverage and was set to air on *Court TV* live. "Lehrer sandbagged the newspapers," says Diamond. "Before we got in there. It was ridiculous, all the crap he pulled." Despite this, Diamond was confident in his abilities. "I had this knack of being able to communicate with a jury…you got to look at what does it take to win this case. If we're going to rely on the basic facts you got through discovery, we can't win the case. Now, if you go with your head down feeling that way, you might as well stay home. I have an old expression: you can lose in the parking lot, you don't have to bother getting out of the car."

The jury selection process centered on the pretrial publicity and what prospective jurors had learned. The court instructed the prospective jurors not to discuss the case amongst themselves; each juror was asked individually about the news coverage and their knowledge of the case and whether what they knew would affect their determination of guilt. The jury pool was a direct reflection of the community, with some educated and others not. Some had money, while others were poor. There were an equal number of men and women and an ample mixture of ethnicities. Diamond's line of questioning throughout the process was consistent, focusing on exposure to the facts as provided by the media. On the fourth day, Ellen Pisnoy, a prospective juror, told the court that prior to receiving the court's instructions, all the prospective jurors had been discussing the facts of the case. She expressed knowledge of Dherran Fitzgerald and his role in the case, as well as Biegenwald's previous murder conviction. By the time the court found this out, fifty jurors had been questioned, with none mentioning this fact. The court tried to identify these jurors by using a random questioning method. "The fifty-fourth prospective juror, Michelle Hugo, confirmed during *voir dire* that even after the prospective jurors were seated, jurors were comparing recollections of newspaper accounts about how the defendant lured young women to go with him, how he had murdered them and how he had been turned in by his friend." It was startling how much information the jury pool knew, long before the trial even began. Thirty-five of forty-seven prospective jurors said they could not be impartial and, as a result, were dismissed. Diamond insisted on asking whether, if they knew Biegenwald had killed before, they would automatically impose the death penalty. It seemed a logical question, but he was barred from asking it. Every challenge for cause Diamond requested was denied, with the judge refusing challenges at the side bar. Diamond exhausted all of his twenty peremptory challenges (dismisses without cause) before the final jury was selected. After two weeks, the jury was seated, and the case was scheduled to be heard before Superior Court judge Patrick J. McGann Jr.

On Monday morning, November 28, under bright blue skies, the media gathered in front of the large Monmouth County Courthouse. Fallen leaves covered the pale green grass of the front lawn as spectators scattered about with the American flag blowing high above them. The courthouse didn't have any of the grandiosity of a large city structure; it was just a brown-brick building with large floor-to-ceiling windows and an impressive flight of steps leading to an entrance surrounded by four large pillars. It was the first day of trial, and everyone was eager to get a glimpse of the "Jersey Shore Thrill Killer."

"The trial got to be a life of its own," says Fagen, "Mainly because of Al Lehrer." The trial would be a milestone of James Fagen's career, as it would have been for any other assistant prosecutor. And many had vied for the opportunity after Richard Biegenwald's arrest. "He [Lehrer] stuck by me," says Fagen. "He saw me put together the affidavit, and knew I was capable of winning this case." According to Lou Diamond, James Fagen was "one of the finest attorneys I've ever been up against." This was to be the trial of the century for Monmouth County—never before had the people of the county seen the likes of Richard Biegenwald. The fear he instilled in the community would last for years. The case now rested on the shoulders of the Irish prosecutor.

While the crowds were outside the courthouse, a black Rolls-Royce drove up with a license plate that read, "Aquitil." Stepping out of the car was Louis Diamond, clothed in a full-length black fur coat with gold and diamond rings on several of his thick fingers. Hollywood Al could have taken a lesson or two from Diamond. However, these antics didn't sit well with the citizens outside. To some, it was simply appalling that a case involving the death of an innocent teenager would be met with such flamboyance.

The trial would take nearly a month to conclude, and each day the courtroom was full to capacity. The courtroom was what one would expect—the walls were made of mahogany, as was the judge's bench and witness stand, which sat just below, to the left, of the judge. The carpet was cream in color, and two desks, one for the prosecution and one for the defense, were directly in front. A stenographer sat typing quickly in front as the judge provided instructions to the jury.

James Fagen's opening statement described how Anna Olesiewicz went to the boardwalk in Asbury Park for a weekend of fun when her life was

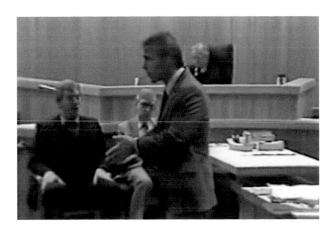

James Fagen, closing statement. *Courtesy Kevin Quinn.*

brutally taken from her by the cold-blooded forty-three-year-old sitting before them. "Mr. Biegenwald," Fagen said, "was...hunting for someone to kill. He found her, and he killed her. He shot her in the head with a .22-caliber gun." The prosecutor told of the body being hidden underneath a mattress in the garage and Anna's head being wrapped in a garbage bag. He indicated that the gun was bought in Florida by Dherran Fitzgerald, and the ammunition was in Biegenwald's bedroom. He said the evidence would show that Biegenwald took a ring from Anna and gave it to his girlfriend, Theresa Smith, who in turn gave it to Biegenwald's wife.

Lou Diamond, in his opening statement, asked the jurors to "pay particular attention to the testimony of Mr. Fitzgerald," a man Diamond described as a necrophiliac or, in laymen's terms, a man sexually attracted to corpses. "After you hear the evidence in this case," Diamond stated, "ask yourselves what would be the difference if the charges were against Fitzgerald." Diamond said, "Fitzgerald had the gun. There were no witnesses in this case. He listed his occupation as a murderer and as a mercenary. Think whether it should be the people versus Fitzgerald." The drama in the courtroom was straight out of a Hollywood movie, with a hardnosed prosecutor and a cocky defense attorney bent on getting his client off, no matter what the cost. Both men were brilliant at what they did, and their statements throughout the process bore this out. At times, it was hard for anyone in the room to believe what they were hearing.

The prosecution called Anna Olesiewicz's boyfriend, Michael Knoblauch, to the witness stand and showed him the ring recovered from Diane Biegenwald's jewelry box. Knoblauch positively identified it as the one he had purchased and given to Anna. Denise Hunter also testified, telling of the night her friend had gone missing, and identified the clothing she was wearing. On cross-examination, Diamond was able to establish from her that Anna "occasionally smoked marijuana, took Quaaludes and used cocaine." The possibility of Anna dying of an overdose was inferred by the defense.

Next was the testimony of Theresa Smith. The papers had reported about her, but never had a photograph surfaced. As she walked in to take the stand, everyone was shocked at how pretty she was. With dark eyes and black hair, she looked elegant in her tailored beige suit with a ruffled maroon blouse. She was soft on the eyes. It seemed unlikely that the disheveled monster before them could attract such a beauty. She calmly sat, raised her right hand and swore to tell the truth and nothing but the truth, "so help me God."

James Fagen, wearing a grayish-colored suit, white shirt and blue tie, wasted no time and began questioning her about Anna Olesiewicz. Smith

said Biegenwald wanted her to look at "his victim from the night before."
She continued by saying, "He told me this was supposed to be my victim.
I was supposed to kill her." He brought her inside the garage, and under
a mattress, Smith saw the lifeless body of Anna Olesiewicz with a green
garbage bag wrapped around her head. "He asked me if I had ever felt a
dead body before." She admitted to touching the body at her boyfriend's
request. It was interesting that Smith used the word "victim," and Fagen
questioned her about it. "I heard [Biegenwald] use the term 'victim' a few
times," she replied. Biegenwald told her a victim was "a person susceptible
to things and easily manipulated." Fagen then asked if Biegenwald ever
explained why he killed Olesiewicz, and Smith replied, "She was there,
so he just shot her." Smith told of the twisted life she had lived while
boarding with the Biegenwalds. She spoke of Biegenwald taking her target
shooting to teach her how to handle a gun. They had spoken at length on
whether she was capable of killing someone, and for a time, the idea was
appealing to the pill-popping Smith. During her tenure in the Biegenwald
household, she was taking pills daily. Smith said Biegenwald had planned
on a different victim the night Anna went missing. Biegenwald had wanted
her to do the killing, not him. Smith had set up a co-worker named Betsy
to be the victim. Betsy and Smith worked in the jewelry department of
Steinbach's in Toms River. The two had gone out after work, and Theresa
was supposed to kill her. "He hoped no one knew she was going out with
me," Smith said.

"Why?" asked Fagen.

Smith replied, "To kill her."

However, things didn't go as planned because Smith couldn't go through
with it. This left Biegenwald disappointed and roaming the Asbury Park
boardwalk. Later that night, she was awakened by Biegenwald standing
beside her bed. He wanted to show her something, but she said she was too
tired. After he left, she peered out the window and saw a human figure in the
passenger's seat of Biegenwald's car.

Smith said that the following morning, she, Biegenwald and Diane visited
his mother in Staten Island. It wasn't until after they returned in the evening
that Biegenwald and Fitzgerald disposed of the body. She knows this because
Biegenwald said he "found a place for the body off a dead-end street."

Under cross-examination, Lou Diamond's questions were centered on
Smith's fascination with Richard Biegenwald, and she admitted to being
enamored with him. "It just sounded like the movies; it was neat. It didn't
sound like real life."

Diamond's response set the woman aback: "Just like touching the body in the garage?"

With a hint of anger in her voice, she replied, "No, that was real life."

Diamond asked, "Was that neat?"

Speaking softly, Smith said, "No, it wasn't."

Diamond spent a good amount of time creating a biographical sketch of Smith for the jury. He wanted them to see the drug-induced party girl Biegenwald was attracted to, not the nice, innocent-looking woman sitting before them. She was a hard-living, freewheeling women who took amphetamines like they were vitamins. Looking at Theresa Smith, Diamond gestured, "You didn't dress like this?"

"No, I didn't," she stated.

Through his questioning, it was learned that Smith had once worked in a punk-style rock band and wore her hair in a red punk cut. "Didn't you wear a dog collar around your neck?"

Jurors could see that Smith was agitated by his questions. "No, I never wore a dog collar," she angrily replied.

Diamond's line of questions were continuously interrupted by James Fagen's objections. Judge McGann cut short Diamond's questioning because he was pushing the limits of cross-examination.

Beginning anew, Diamond focused on the events surrounding the murder of Anna Olesiewicz. Once again, he was attempting to discredit Smith. He was able to get Smith to admit to cleaning caked blood from the upholstery of her Plymouth Valiant with ammonia. "Didn't that bother you?" Diamond asked.

"It made me feel very uneasy," she responded. Earlier in her testimony, Smith had revealed that Biegenwald had burned Olesiewicz's wallet, which contained her identification. Diamond asked why she didn't go to the police then and she said, "Because I was afraid it would get all messed up and I would die, too."

When Dherran Fitzgerald took the stand as the state's witness, his plea deal had already been settled. The state recommended ten years in prison, but according to James Fagen, Judge McGann liked Fitzgerald and gave him five, with which Fagen was comfortable.

Fitzgerald looked better than he had at his arraignment, and it looked as if he had put on a few pounds; apparently, prison food was agreeing with him. He was wearing a gray wool suit with a green T-shirt underneath, and his hair was freshly cut and combed. It looked as if he had just shaved, and he sat erect. Standing on the opposite end of the courtroom, Fagen began

his line of questioning. "Do you have any information in connection about the death of Anna Olesiewicz?"

Fitzgerald answered, "Yes."

"What is that?"

"Well," clearing his throat, Fitzgerald said, "I first became aware of Anna Olesiewicz not by name but by seeing the body."

Fagen then asked, "When did you see that body?"

Fitzgerald said it was "on a Sunday morning, the weekend prior to Labor Day." He pulled into the driveway about five o'clock in the morning and saw Richard Biegenwald standing there. "He told me he had a problem." Pausing, as if for effect, he then said, "The problem turned out to be the body of Anna Olesiewicz." He said his friend asked him to help get rid of the body, to which he agreed. Fitzgerald said he then went inside, had breakfast and went to sleep. "When darkness had fallen," they disposed of the body in a vacant lot behind a Burger King restaurant in Ocean Township.

Fagen then inquired about the basement and the tools and equipment there. "Besides the normal maintenance of the house," Fitzgerald said, "we worked on maintenance of weapons, alterations of weapons…and experimentation of weapons."

Diamond, on cross-examination, used the same tactics to discredit Fitzgerald as he had with Smith.

George Susco, Theresa Smith's boyfriend, testified about his conversations with Smith and how Smith had come forward to his wife with the information about Anna Olesiewicz's murder.

Kevin Quinn, wearing a gray suit with a white-colored shirt and a cream-colored knit sweater, spoke at length about the crime scene at the 507 Sixth Avenue apartment. Standing before a bulletin board with a schematic of the apartment complex, Fagen asked Quinn several evidentiary questions. A video taken of the apartment was also presented, and each section was explained as the jury watched. The video went from room to room, revealing what authorities had found. A video close-up into one of Biegenwald's drawers revealed a black semiautomatic handgun with a silencer attached to it and boxes of ammunition. Another section showed Fitzgerald's kitchen with a sawed-off shotgun and an explosive device sitting on a shelf as if on display. As the video played, it was evident that the residences of Biegenwald and Fitzgerald were littered with weapons, explosives and poison. Several pieces of key evidence were presented as well, including the .22-caliber murder weapon.

After the state rested its case, Lou Diamond called before the court three state prisoners to refute Dherran Fitzgerald's testimony. Terence James, an

inmate at Trenton State Prison and a person believed to be a schizophrenic, testified that Dherran Fitzgerald had said he killed Olesiewicz. According to James, "[Fitzgerald] said, 'This is one of the girls [pointing at the newspaper picture]' that he killed," James testified. Continuing, James said Fitzgerald told him the prosecution was so eager to "get Mr. Biegenwald, they would believe anything he told them." Two other inmates were brought in and testified how Fitzgerald told them he "enjoyed killing women." On cross-examination, Fagen was able to establish that Richard Biegenwald had given all three witnesses Lou Diamond's address, inferring that he was soliciting their help.

Defense witness Dr. Azariah Eshkenazi, a forensic psychiatrist who examined Richard Biegenwald three times during the course of the year, took the stand. Eshkenazi said he had spent eight or nine hours with Biegenwald and had extensively reviewed his medical history. His analysis was that Biegenwald had suffered abuse as a child and had been institutionalized at the age of eight and diagnosed as schizophrenic. He told the jury of Biegenwald's twenty electro-convulsive shock treatments and said that Biegenwald had been treated for headaches by being constricted in a bed under tight, wet, cold sheets. The doctor said that Biegenwald told of urinating on himself to keep warm. In his opinion, Richard Biegenwald was suffering from a severe personality disorder known as anti-social personality with paranoid traits. Eshkenazi explained that at the time of the murder, Biegenwald "lacked the capacity to appreciate the wrongfulness of his act emotionally, though not intellectually." Explaining further, he said, "Intellectually, he knew what he was doing, but he certainly did not appreciate that it's wrong to kill somebody." Because of his personality disorder, Eshkenazi asserted, Richard Biegenwald lacks the appreciation of the wrongfulness of his actions and the ability to conform to the requirements of the law.

On Tuesday, December 6, 1983, after hours of testimony and numerous witnesses on both sides, Lou Diamond rested his case. The closing arguments from both the prosecution and defense were straight to the point and reasonably short. Diamond compared the state's witnesses, who said Biegenwald did the killing, to those who said it was Fitzgerald. He pointed to the murder weapon being found in Fitzgerald's apartment and suggested there was reasonable doubt about whether Richard Biegenwald had done the killing. Fagen, on the other hand, implored the jurors to use their "common sense and logic." Pointing to the jury deliberation room, he said, "When you go back in there, if you do that, the state, I think you'll have to agree, has proven its case beyond a reasonable doubt."

The following morning, at 10:15 a.m., after spending five hours deliberating, the jury had reached a verdict. Richard Biegenwald was guilty of murder, gun possession and drug charges. Several minor charges surrounding drug possession had been dropped by Judge McGann after the state rested, as McGann said the state did not prove its case with these complaints.

On Wednesday, a separate trial for the death penalty was held, and after six and a half hours of deliberation, the jury imposed capital punishment.

ON CHRISTMAS MORNING 1983, the weather was brutally cold, registering 1.9 degrees. Families were celebrating the joyful occasion, while Robert Olesiewicz, like Estelle Sladowski twenty-five years prior, gathered together with family and friends to remember his loved one. The solace for Robert Olesiewicz was that the man responsible for his daughter's disappearance was behind bars.

As 1983 came to an end, James Fagen and Billy Lucia thought back on the year and how a cold case had turned into a complex investigation involving a serial killer. It was a challenging year, to say the least. However, they were not done. They still had to prosecute Richard Biegenwald for the other victims, and more investigative legwork would certainly be needed.

The trial in the death of William Ward was moved to Burlington County, to take place at the courthouse in Mount Holly. This trial was quicker than the first, and on Thursday, February 16, 1984, the jury found Richard Biegenwald guilty of murdering William Ward. The jury, however, was deadlocked on whether to impose the death penalty. In light of this, the judge ruled in the matter and gave Biegenwald life in prison.

The death penalty conviction for Anna Olesiewicz's murder was appealed and took a series of twists and turns. Throughout the spring, summer and fall, newspapers were filled with headlines about Richard Biegenwald: "Prosecutor Plans Appeal on Biegenwald Decision," "Biegenwald Is Given New Death Sentence in Murder in Jersey" and "Jury Sentences Convicted Multiple Murderer to Death." And just as all of this was unfolding, Richard Biegenwald pleaded guilty on Thursday, September 13, 1984, to murdering Maria Ciallella and Deborah Osborne. Judge Patrick McGann Jr. accepted his plea and sentenced Biegenwald to thirty years in prison for each murder—the maximum sentence possible as their deaths had occurred prior to New Jersey's reinstatement of the death penalty.

Chapter 20

Questions but No Answers

Death row is an isolated section of Trenton State Prison, and it is called the Capital Sentence Unit. Prisoners on death row have a private indoor and outdoor recreation space, where they are periodically allowed to gather. There is no library, but a pushcart with a small assortment of books is wheeled around for their reading pleasure. Meals are administered individually and served on paper plates with plastic utensils; the plates are pushed through a two- by three-foot window in their cells. No personal decorations are allowed on the cinder-block walls, which can be painted white, blue or gray. There are no carpets but rather cold, hard concrete floors. The only clothing allowed to be worn are khaki pants and a matching shirt or T-shirt.

Richard Biegenwald's cell was approximately six by twelve feet, with thick metal bars and white-painted walls. A small desk with a stool sat alongside one wall, and he had a small stand with a black-and-white TV and an AM/FM radio. In the corner was a steel sink, a wall-mounted toilet and a single-mattress bed. At his desk, sitting on his stool, Biegenwald would smoke his unfiltered cigarettes. He had always been a chain smoker but seemed to be smoking more now that he was on death row. Guards patrolling would see him sitting there, smoking cigarette after cigarette. He smoked so much that "his white walls turned yellow," says Guy Spitale, a Trenton State prison guard. "His cell was so filled with smoke you could hardly see him sitting there."

For the next several years, Biegenwald's life would be controlled by a strict schedule, which included a 6:30 a.m. wake-up call followed by breakfast,

which could be eggs, toast and bacon or oatmeal and white bread. At 8:30 a.m., he was allowed to visit the interior recreational area known as the "Kennel." Prior to entry, he had to be strip-searched, but more often than not, he preferred to remain in his cell. Lunch was served at 11:00 a.m., and afterward, he was offered access to the outside recreation area. When he chose to go, he kept to himself and sat quietly smoking a cigarette. Visitation for death row inmates was twice a month for an hour. Guy Spitale says, "[Biegenwald] never had a personal call or window visit."

For eight years, Richard Biegenwald sat on death row awaiting his fate. On August 8, 1991, the New Jersey Supreme Court cited errors in the jury selection process of his death sentence trial and ordered a new trial. On March 15, 1993, a jury in the third sentencing trial couldn't reach a unanimous decision (a requirement for the death sentence). In turn, the court imposed a life sentence with 30-year parole ineligibility. Lou Diamond and his defense team had achieved their objective: Richard Biegenwald's life was spared. Later that year, Biegenwald pleaded guilty to killing Betsy Bacon; the sentence was irrelevant, as Richard Biegenwald was ineligible for parole for over 110 years.

He was now back in the general prison population and kept to himself. The sexually explicit letters Diane Biegenwald had once written were long gone. By all accounts, his wife and daughter never came to visit him. In a prison with more than one thousand people, Richard Biegenwald was alone. Lou Diamond had once suggested that Biegenwald's life should be spared so he could be studied; however, the American prison system doesn't work that way.

Probably the one person who knows the most about Richard Biegenwald and the only person whom the killer himself trusted with his secrets was Lou Diamond. Years later, after the trial and Biegenwald's death, while sitting on a comfortable couch in his living room, Lou Diamond shared a few conversations he had with his client. Diamond said Biegenwald spoke of killing upward of one hundred people. "He used to try out his altered handguns, equipped with a silencer, on prostitutes...He was a fan of the New York City trash cans with the mess bottoms, which were designed to allow rain water to flow out." These Biegenwald used to dispose of bodies "off of Sandy Hook, where the crabs would eat them...he was also a fan of the pine barrens."

Diamond spoke of a mail package he received from Richard Biegenwald after the trial. "He was a true sociopath, but brilliant...he wrote me a treatise he wanted to see if I could get published...one of the things was

on milk cartons. [They] say there are 300,000 missing children in America today. What they don't say is that there are 1.4 million missing people. The other 1.1 million are adults." The question Biegenwald posed was: "What do you think happens to them?" After reading the document, Diamond was led to believe that Biegenwald, "as in the movie *Coma*...was shipping body parts" overseas, possibly to "Brazil and Switzerland...for transplants. The guy was cold as ice, but a brilliant, brilliant guy." As evidenced by the victims we know he killed, the bodies were disposed of in such a way that he would have never been tied to them. If not for a betrayal of trust, Richard Biegenwald might never have been caught. If the prosecution had only accepted Diamond's plea offer in exchange for twenty-five bodies, we might have more insight into the man and his victims—and possibly help in identifying additional ones.

After the trial, James Fagen took a ride to Trenton State Prison while Biegenwald was on death row. In a lockdown room with a piece of thick Plexiglas separating them, Fagen said, "If [you] give us these bodies, you will not be charged. I will not charge [you]."

Looking directly at Fagen with his piercing blue eyes, Biegenwald said, "You don't really think I'm going to do that, do you?"

On another occasion, Lou Diamond and James Fagen went to Trenton State to speak with Biegenwald about the cable TV station HBO being interested in doing a special on him. After making the two wait for over an hour, he sent word through a guard that he was not interested. In 2008, at sixty-seven years old, the serial killer died from lung cancer and kidney failure caused by years of heavy smoking. With his passing, it is almost certain we will never know the number of victims murdered by Richard Biegenwald.

About the Author

John E. O'Rourke was born in Pequannock, New Jersey, and raised in the Passaic County town of Wanaque. He is a retired New Jersey state trooper with twenty-six years of experience with the elite organization. During his distinguished career, he conducted hundreds of criminal investigations ranging from criminal trespass to murder. He is the author of *Jersey Troopers: Sacrifice at the Altar of Public Service* and *New Jersey State Troopers: 1961–2011, Remembering the Fallen.*